Algonquin
Souvenir

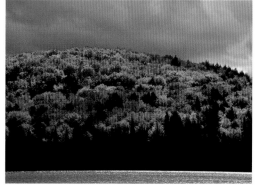

Algonquin
Souvenir

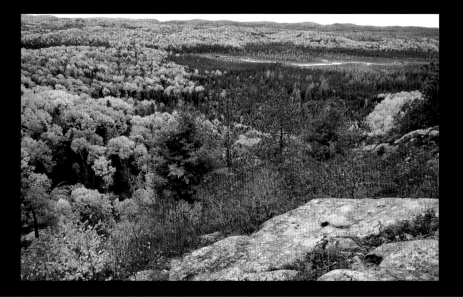

Michael Runtz

The BOSTON
MILLS PRESS

For Ann, whose love was brought to me by Algonquin

Acknowledgments

For my familiarity with Algonquin I owe thanks to many: Ron Pittaway, for convincing Dan Strickland and Ron Tozer to employ me as an Algonquin Naturalist in 1972; Dan Strickland and Ron Tozer, for hiring me and for sharing their friendship and vast knowledge of and passion for Algonquin over what has suddenly become many years; former Park Superintendent Ernie Martelle and current Park Superintendent John Winters, for your support and for providing access to Algonquin's more remote regions; my sons, Harrison and Dylan, for your understanding and patience, especially when I dragged you along on those frequent forays into the Park; my good friends Rory MacKay and Bill Crins, for sharing your knowledge, infinite wisdom (on occasion enhanced by single malt), and many Algonquin adventures with me; and all those who have encouraged, supported, and assisted me through the years. And to darling Ann, thank you for enriching my life with your beauty and love.

A BOSTON MILLS PRESS BOOK

Copyright © 2007 Michael Runtz

Published by Boston Mills Press, 2007
132 Main Street, Erin, Ontario N0B 1T0
Tel: 519-833-2407 Fax: 519-833-2195

In Canada:
Distributed by Firefly Books Ltd.
66 Leek Crescent
Richmond Hill, Ontario, Canada L4B 1H1

In the United States:
Distributed by Firefly Books (U.S.) Inc.
P.O. Box 1338, Ellicott Station
Buffalo, New York 14205

The publisher gratefully acknowledges the financial support for our publishing program by the Government of Canada through the Book Publishing Industry Development Program.

Library and Archives Canada Cataloguing in Publication

Runtz, Michael W. P
Algonquin souvenir / Michael Runtz.

ISBN-13: 978-1-55046-494-8
ISBN-10: 1-55046-494-9

1. Biology — Ontario — Algonquin Provincial Park — Pictorial works.
2. Algonquin Provincial Park (Ont.) — Pictorial works. 3. Algonquin Provincial Park (Ont.). I. Title.

QH106.2.O5R854 2007 578'.09713147 C2006-906789-9

US CIP available upon request.

Design by Gillian Stead

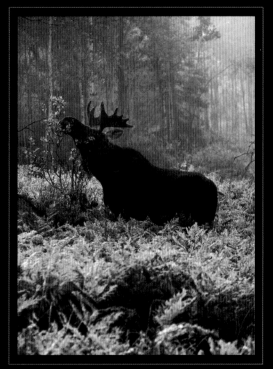

Bull moose near Opeongo Lake

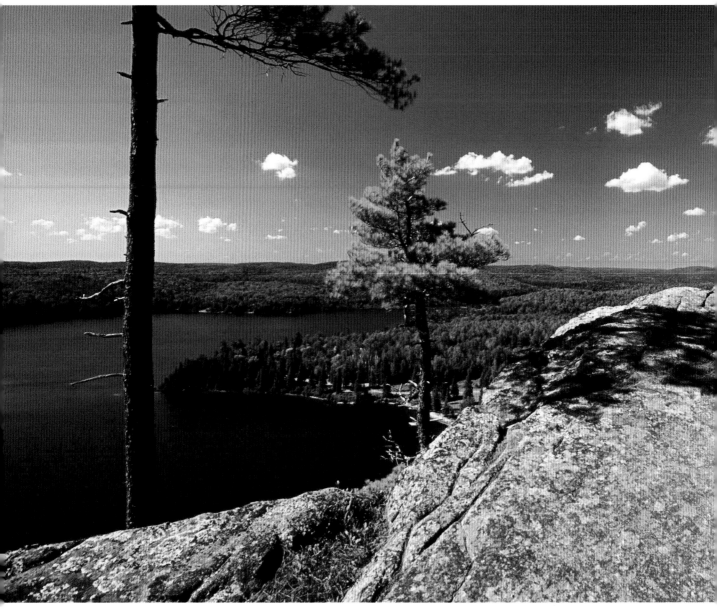

Whitefish Lake from Centennial Ridges Trail

Introduction

I was but a few years old when my parents took me to Algonquin to see the famous fall colours and the white-tailed deer that boldly coerced handouts from park visitors along Highway 60. I have no memory of the three-hour drive from our home or of the world-renowned autumnal splendour, but those giant creatures tugging salted crackers from my hand left a lifelong impression.

That is what Algonquin does — it etches new and permanent memories with each and every trip. These arise from an inexhaustible source: a towering bull moose sways its way across a frost-kissed bog, its antlers glowing orange as they greet the rising sun; a family of otters huffs and snorts indignantly at the intrusion of your cedar-and-canvas canoe as it silently rounds the bend of a winding river; a flaming orange-and-red sea of rolling hardwood hills reveals itself as you step out onto a rocky precipice at the end of a forest-trail climb; in the silence

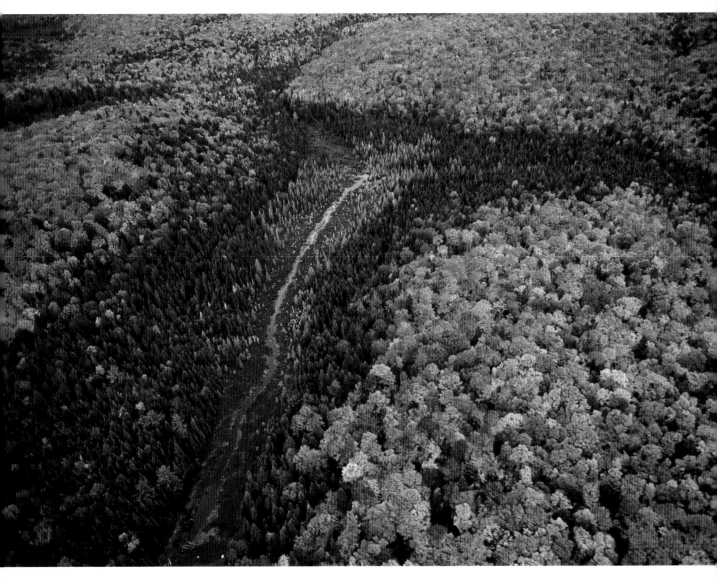

October in the western highlands

of a snow-drenched spruce forest, under a sky so blue that it looks heavy, a flutter of feathers brings a gentle Gray Jay to your outstretched hand; or while contemplating a star-dappled night sky your thoughts are stolen by the soul-stirring howls of an Algonquin wolf. In all seasons, in all habitats, and at all times of day, Algonquin breathes memories into your psyche.

The Park resides atop a dome of ancient Canadian Shield rock massaged by two billion years of wind, snow, rain and ice, its rugged face punctuated by thousands of sparkling lakes, tranquil ponds, gentle streams, and determined rivers. Located deep in the heart of a vast forest region where hardy northern conifers and southern broad-leaved trees mingle freely, the 3,300 square miles embraced by the Park are home to more than 1,000 species of plants, 275 species of birds, 53 species of mammals, 40 species of reptiles and amphibians, and 78 species of fish, not to mention myriad insects and other life forms.

However, there is much more to Algonquin than the sum of its near-infinite elements. When you meet Algonquin, you sense a great presence, an aura that touches you with its agelessness, its permanence, and with Nature's wisdom.

May the following images arouse in you the sensations of joy, awe and humility that are my true souvenirs of this incomparable park.

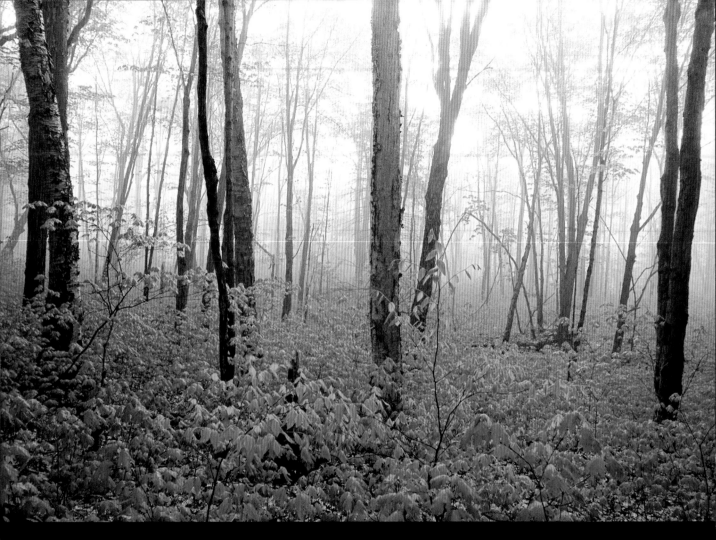

July hardwoods, Mizzy Lake Trail

OPPOSITE: White pine, Tea Lake

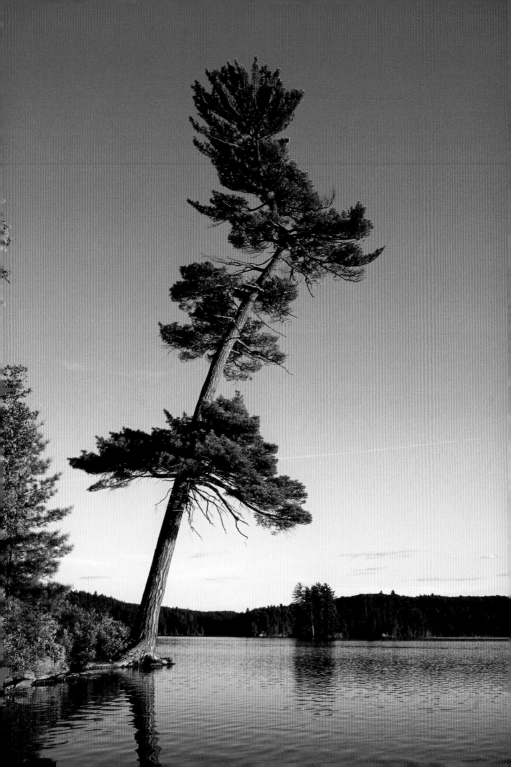

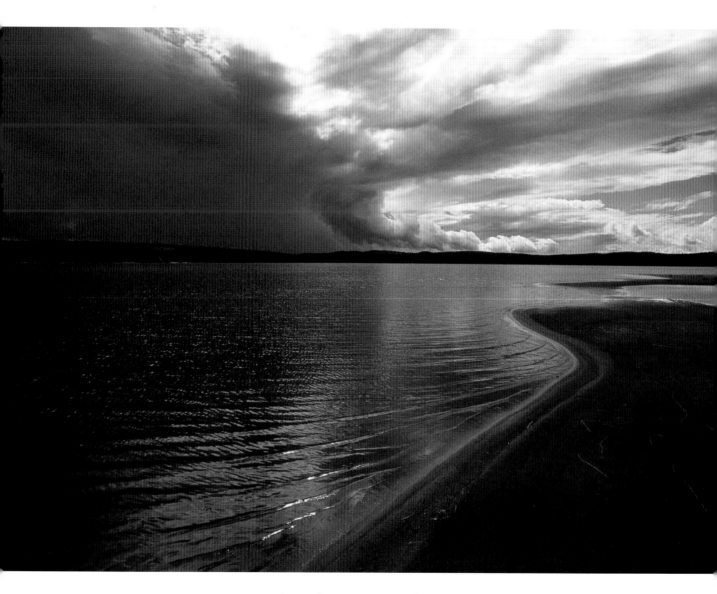

Storm brewing over Radiant Lake

OPPOSITE: October reflections, pond near Bluff Lake

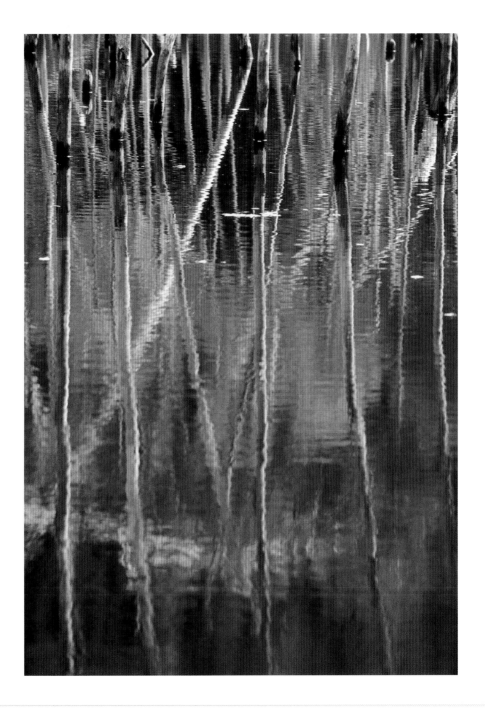

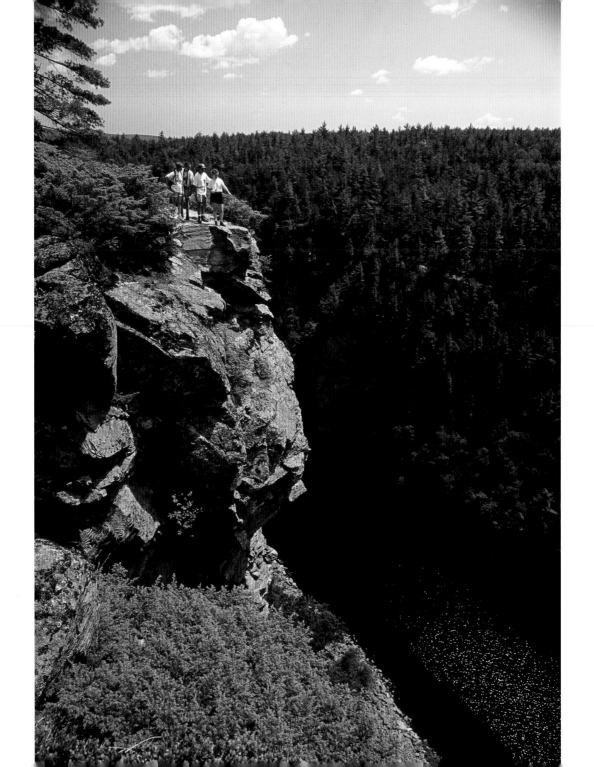

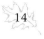

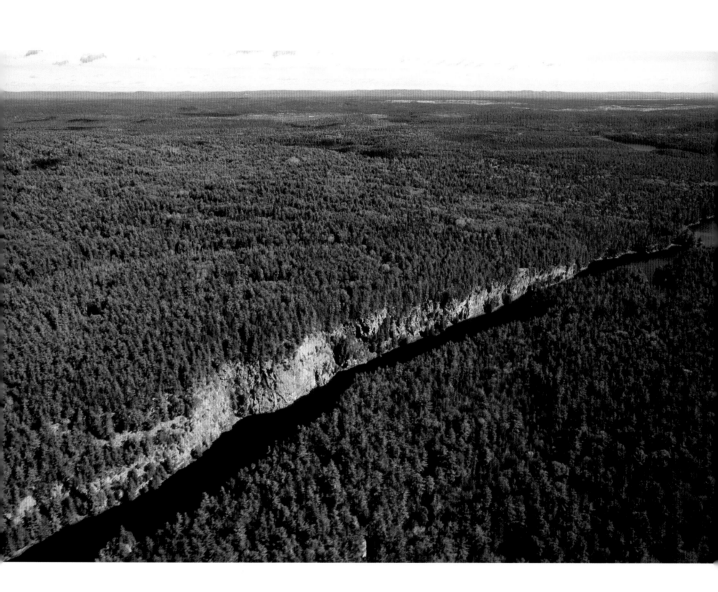

Barron Canyon aerial

OPPOSITE: Barron Canyon Trail

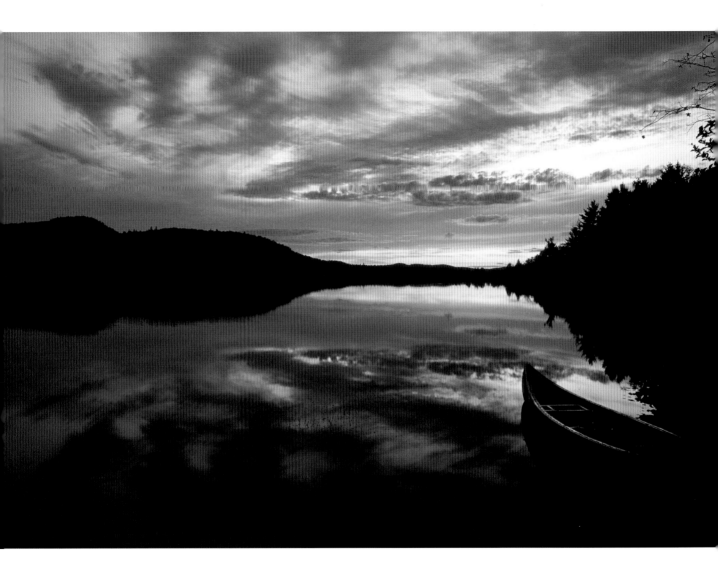

Sunset on Booth Lake

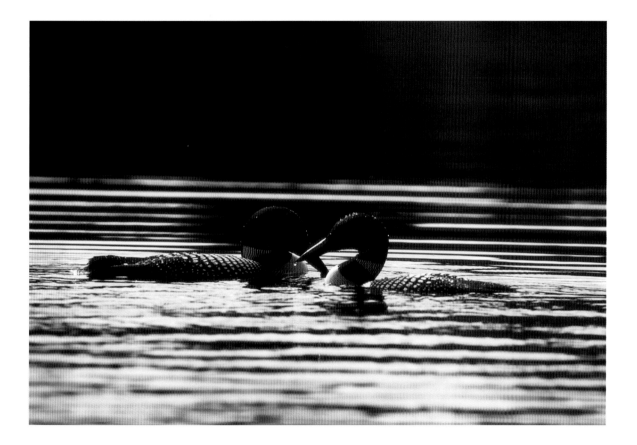

Common Loons, Brewer Lake

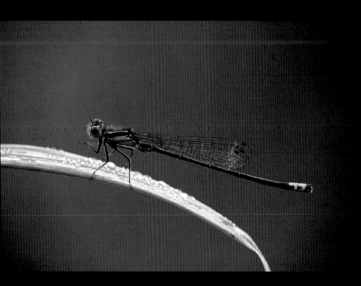

Eastern Forktail, Pewee Lake

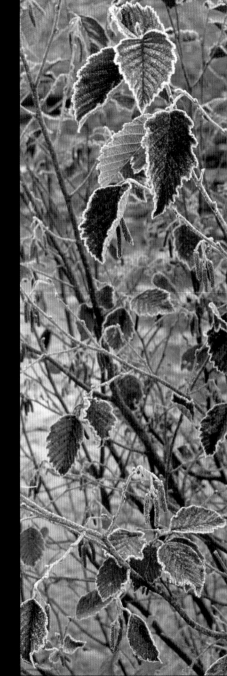

Frost on Speckled Alders, Grand Lake

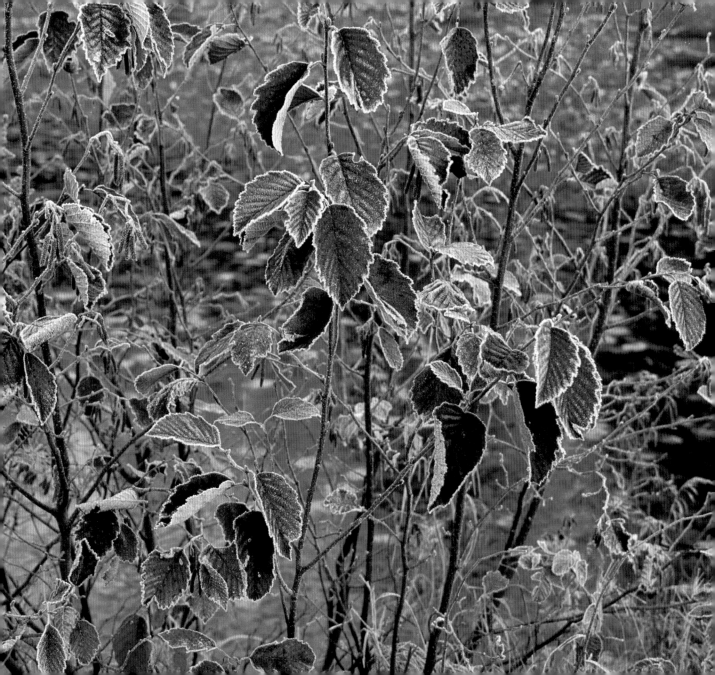

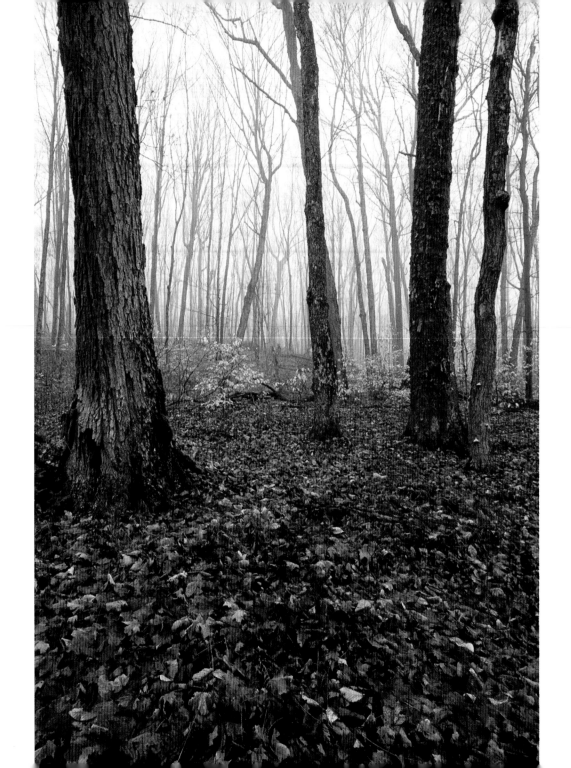

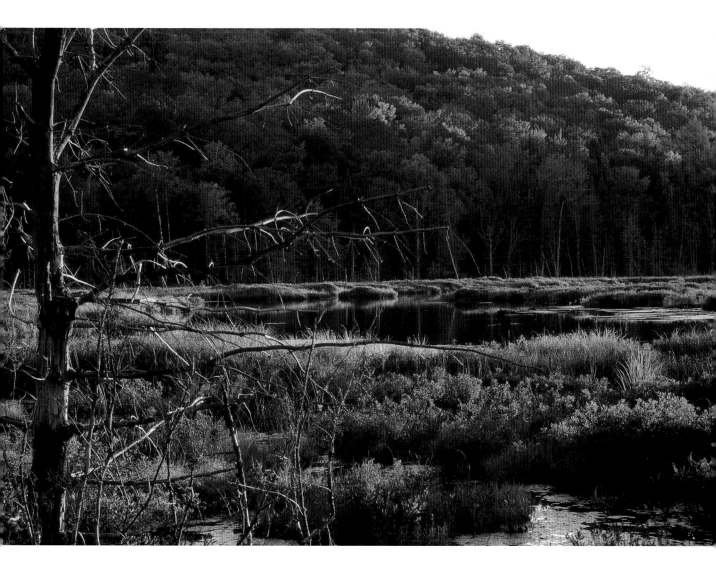

October pond near Vesper Lake

OPPOSITE: November hardwoods, Brewer Lake

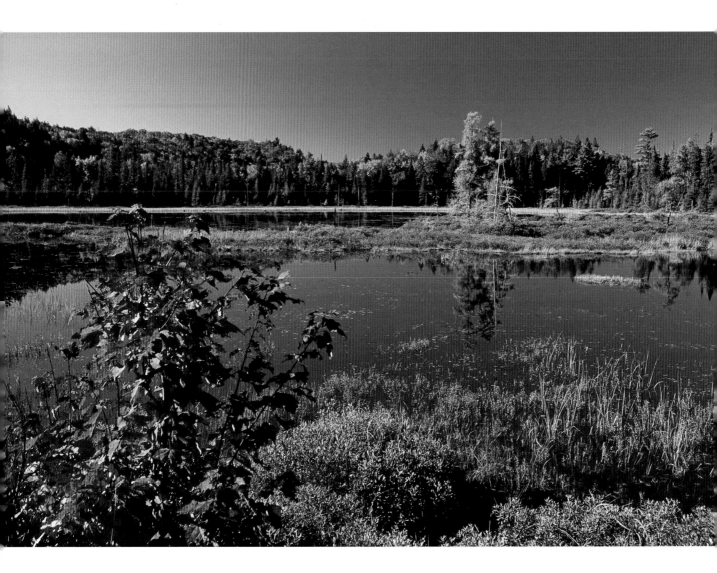

Pond on Ahme Creek

OPPOSITE: Precambrian rock, Petawawa River

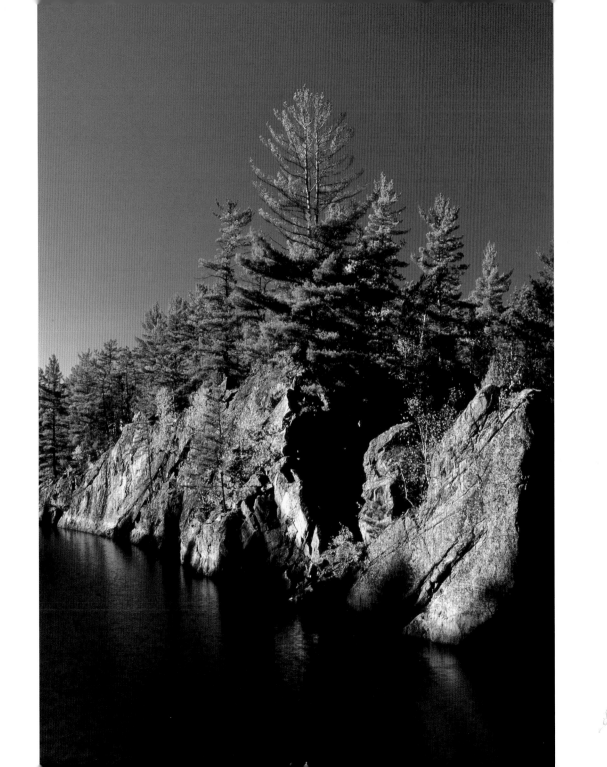

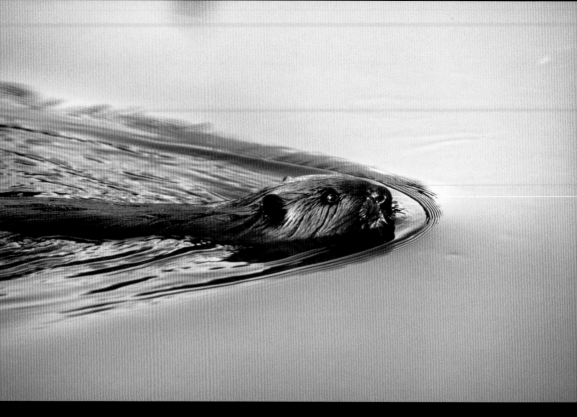
Swimming beaver near Clarke Lake

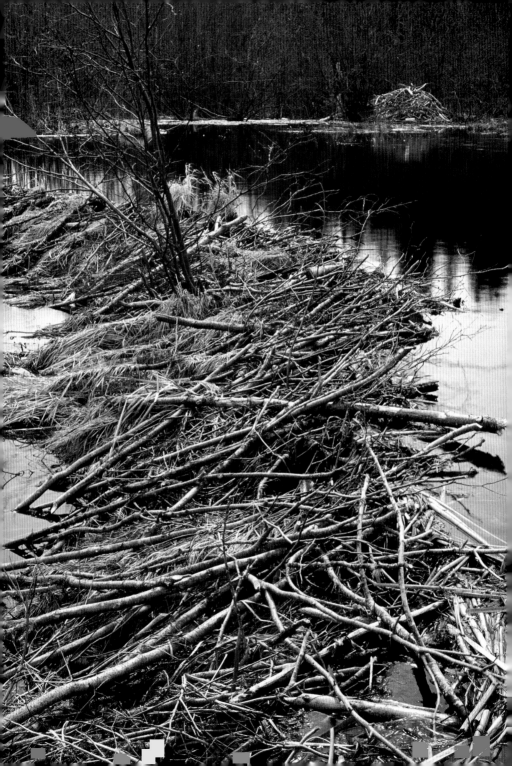

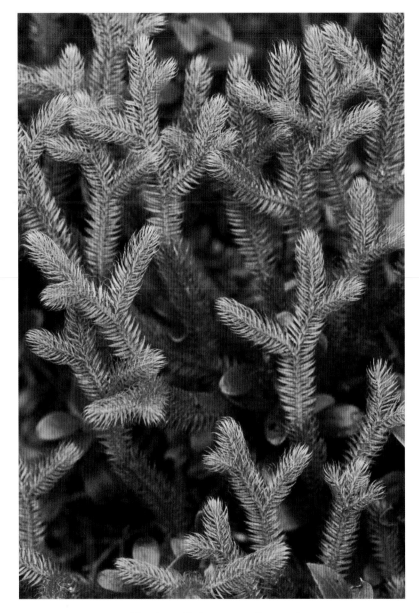

Wolf's-claw Clubmoss, Lake Louisa

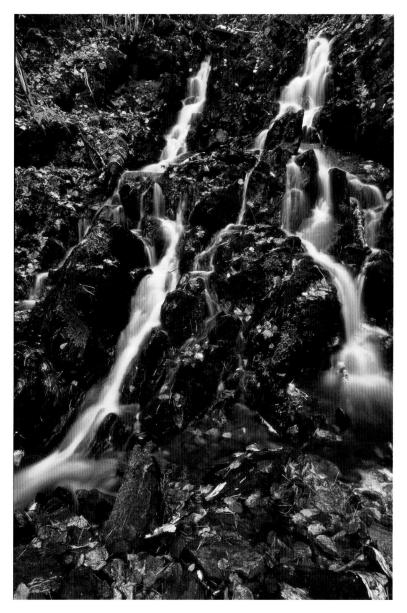

Cascading stream, Greenleaf Lake

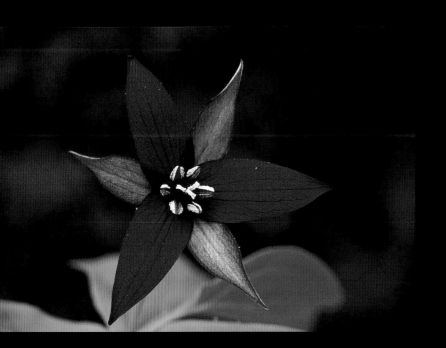

Red Trillium

Sunset, Tanamakoon Lake

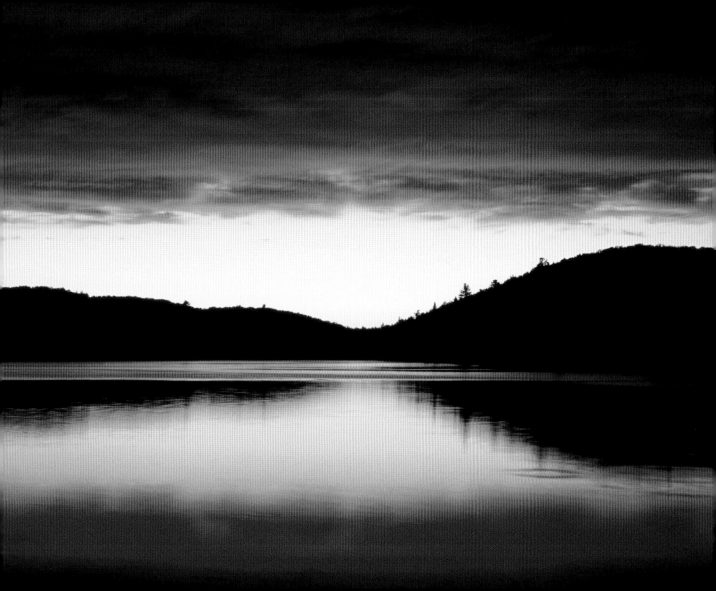

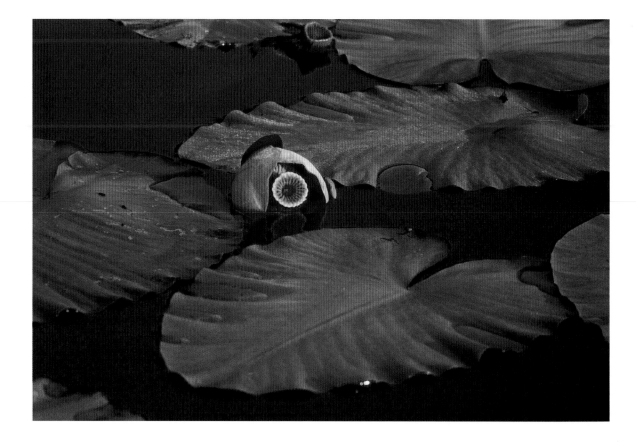

Bullhead-lily, Ring-neck Pond

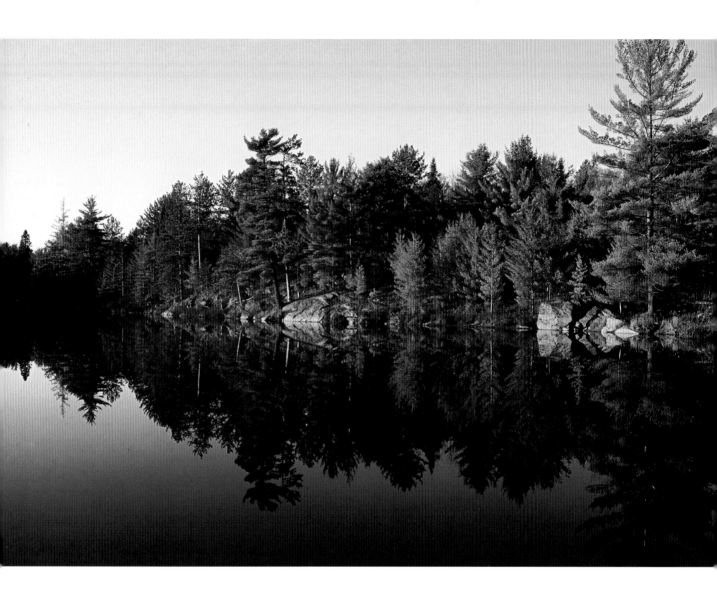

Eos Lake

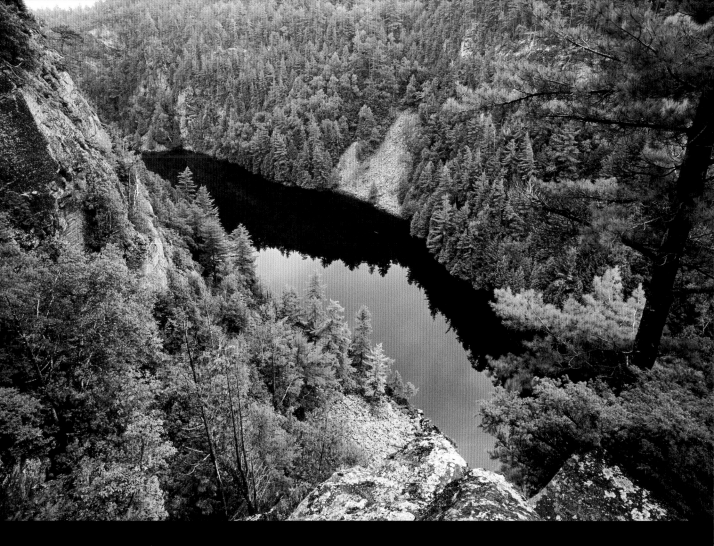

Barron River, Barron Canyon Trail

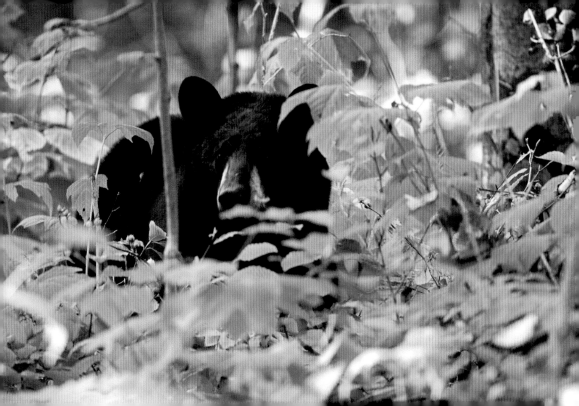

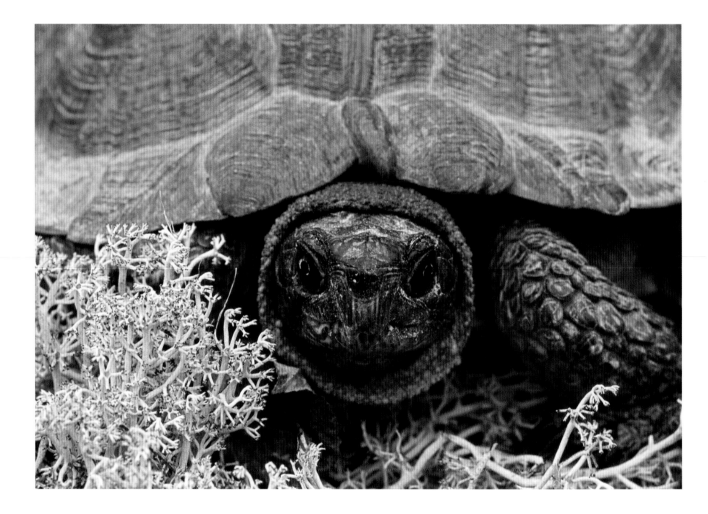

Wood Turtle, Lake Travers

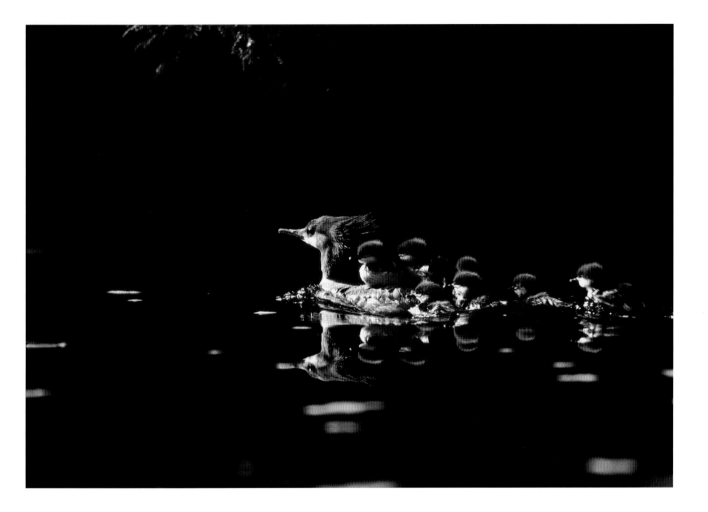

Common Merganser brood, Barron River

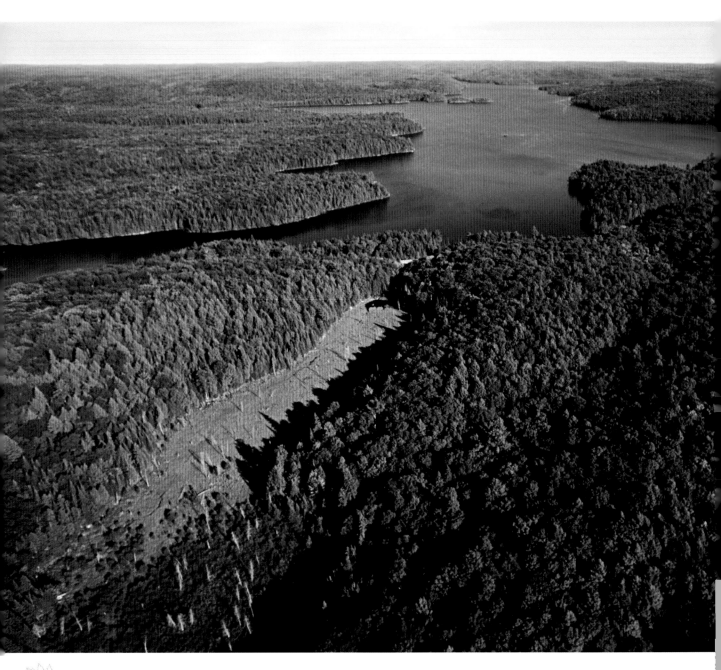

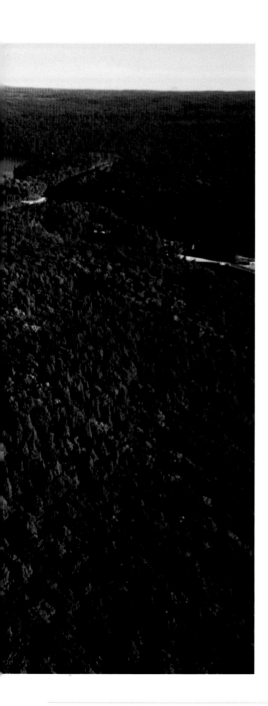

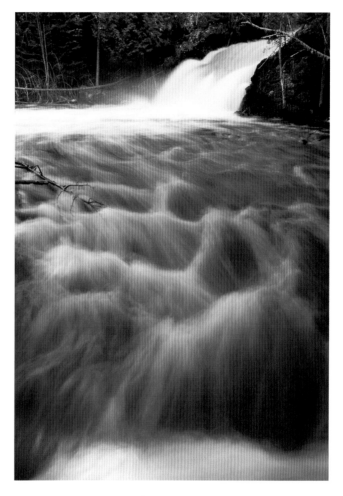

High Falls, Bonnechere River

Smoke Lake aerial, June

Cardinal-flower, Lake Travers

Grand Lake in October

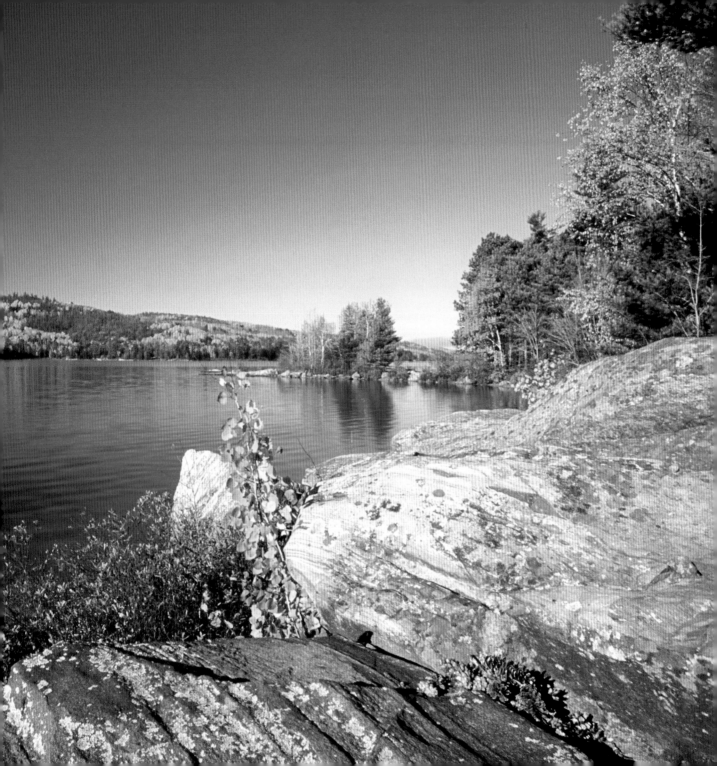

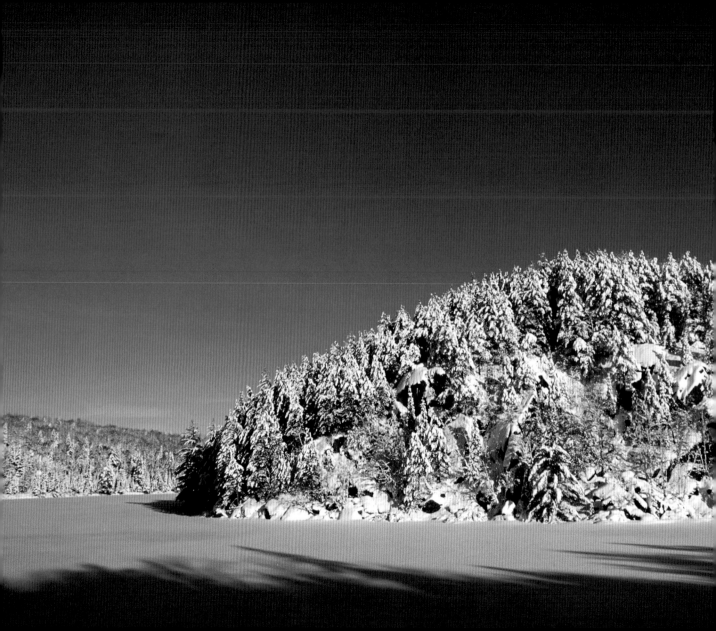

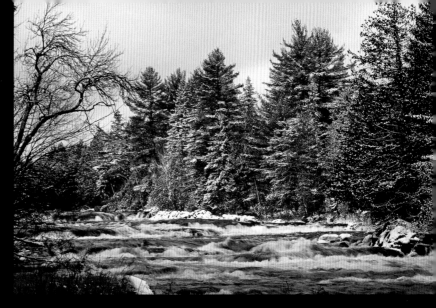

Poplar Rapids in December

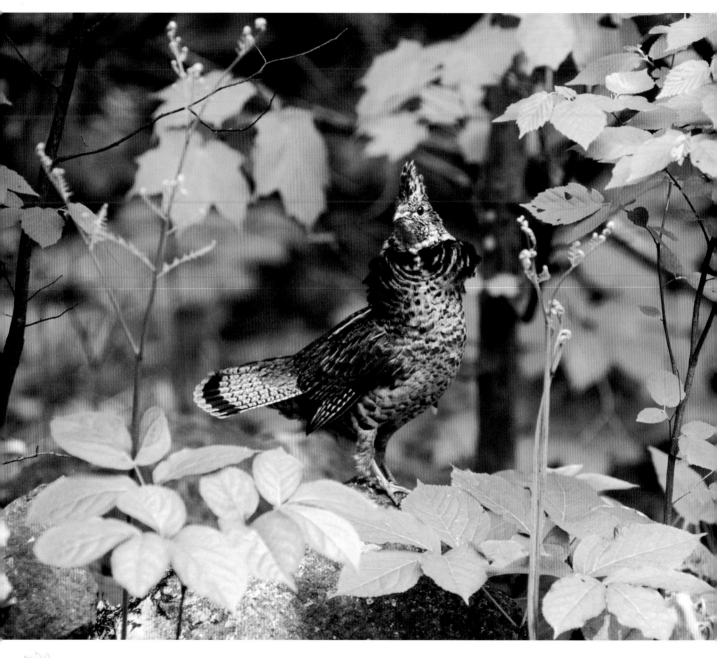

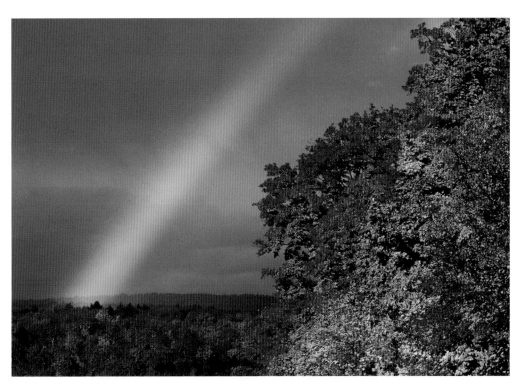

Pot of Gold, Smoke Lake hills

Ruffed Grouse, Crow River

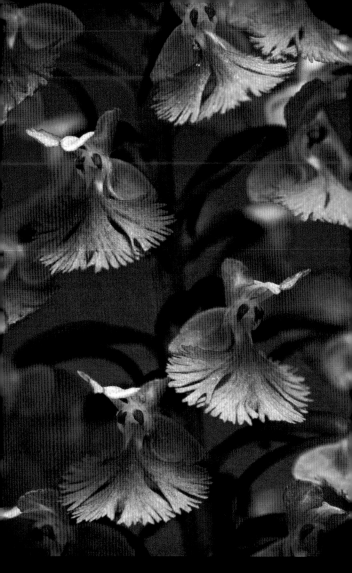

Purple-fringed Orchid, Schooner Rapids

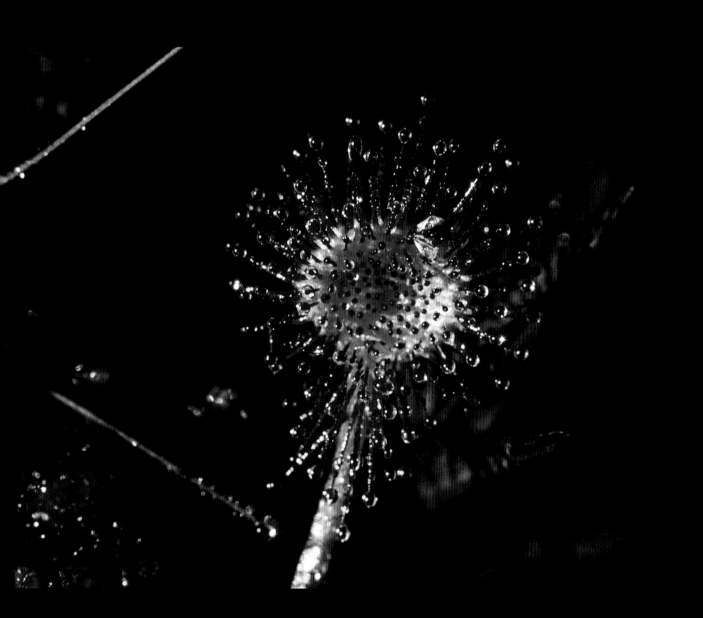

Round-leaved Sundew, Pewee Lake

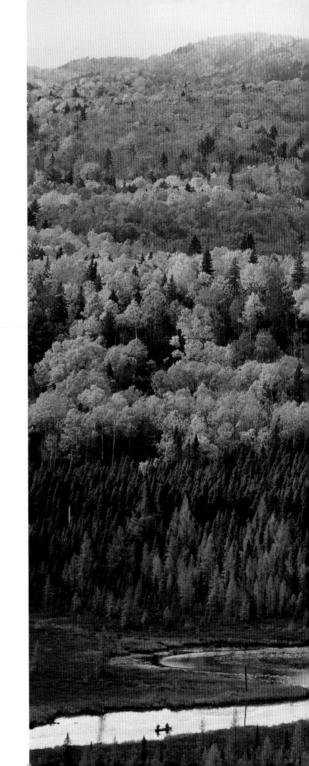

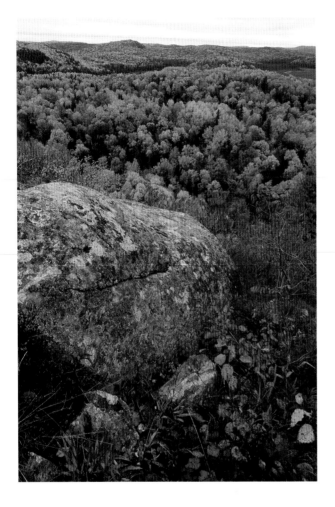

October splendour, Opeongo Lookout

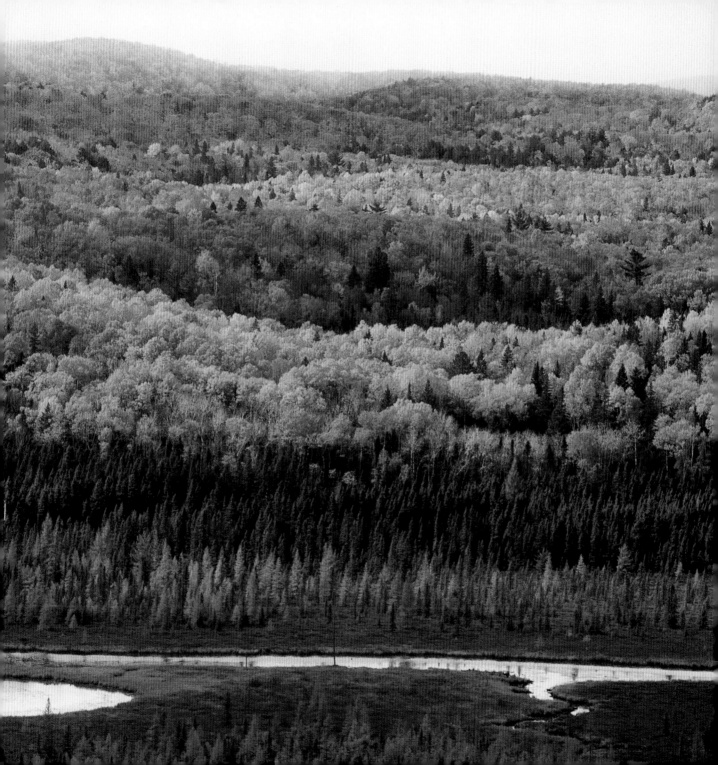

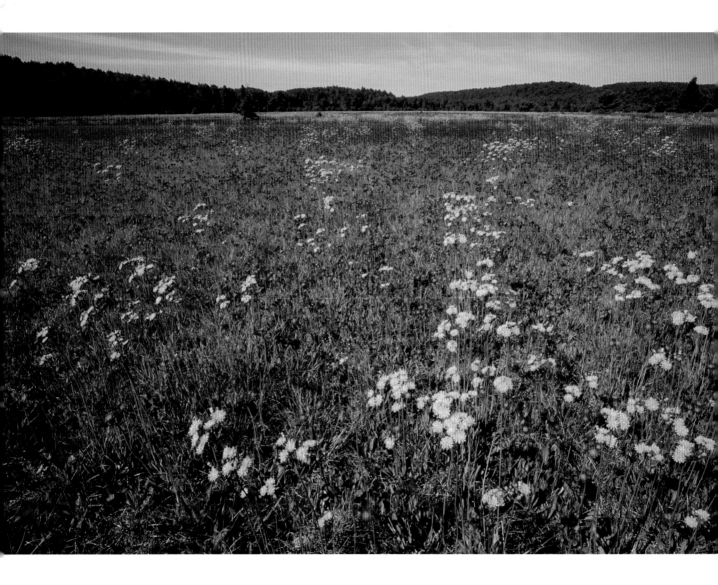

June Hawkweeds, Mew Lake Airfield

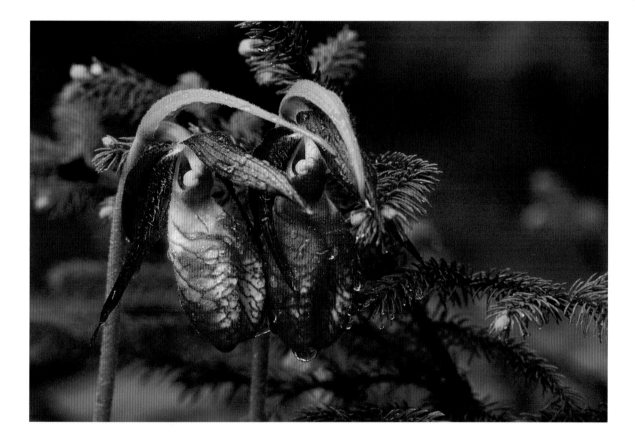

Pink Lady's-slippers, Source Lake

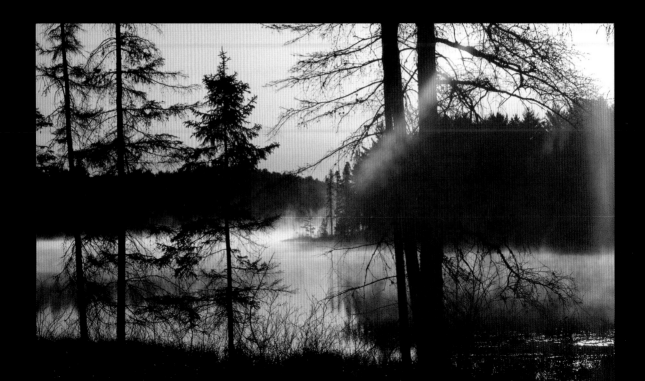

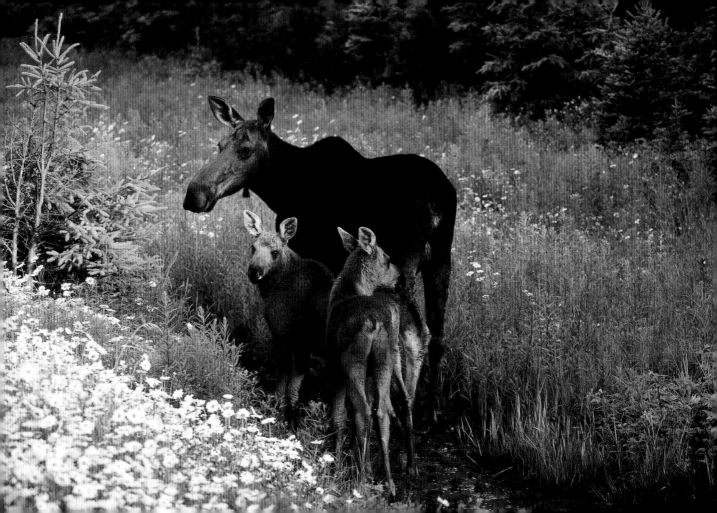

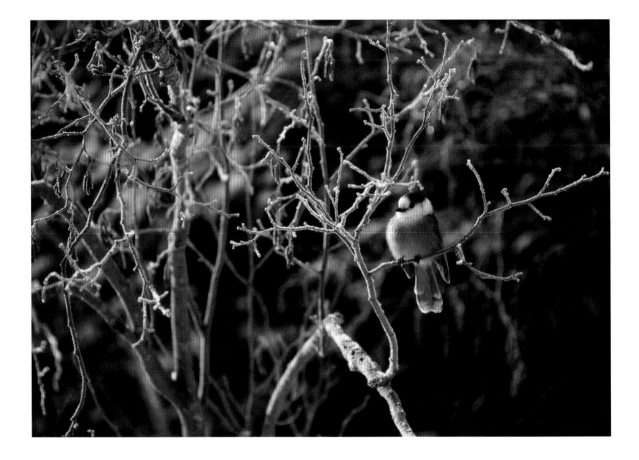

Gray Jay, Forbes Creek

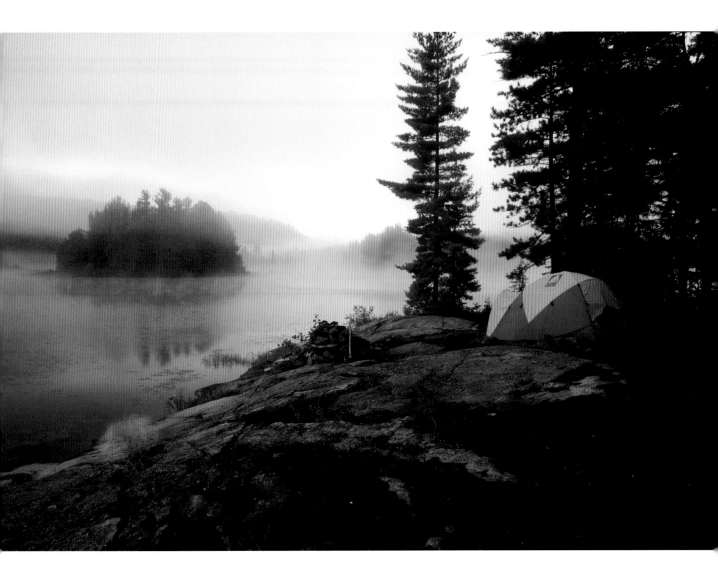

Fork Lake campsite

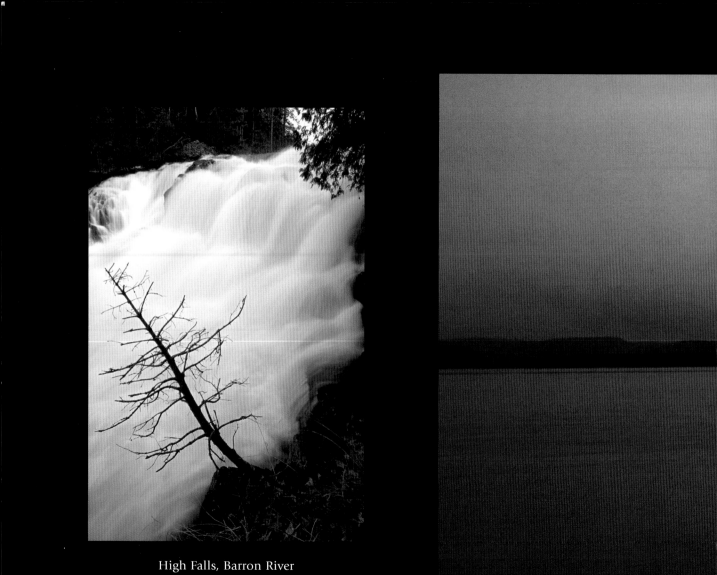

High Falls, Barron River

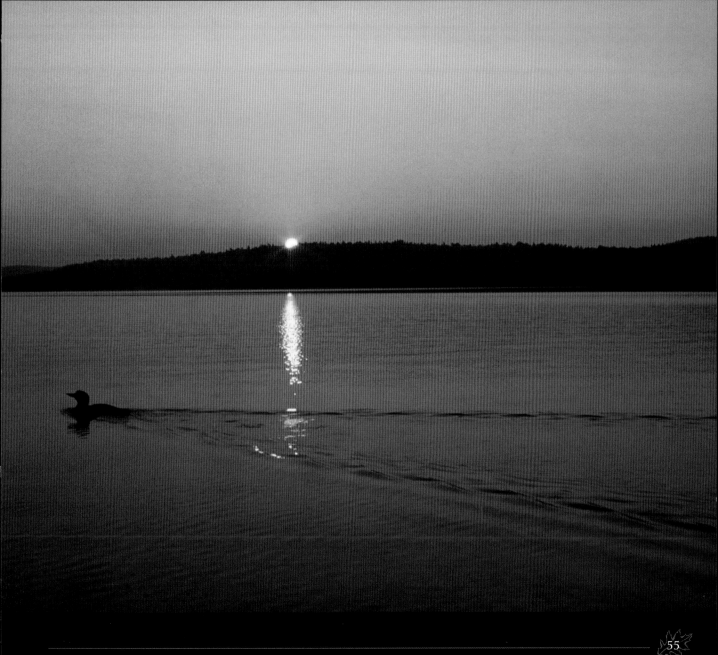

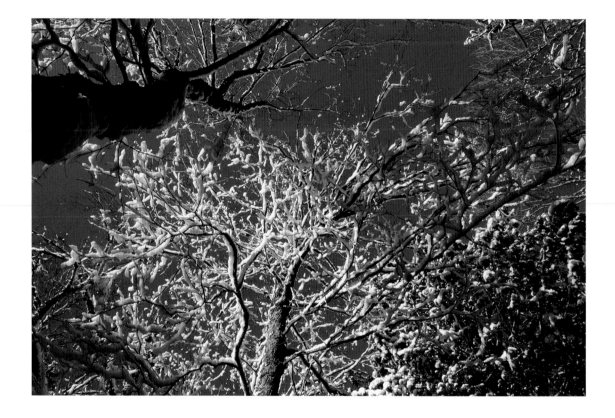

February hardwoods, Brewer Lake

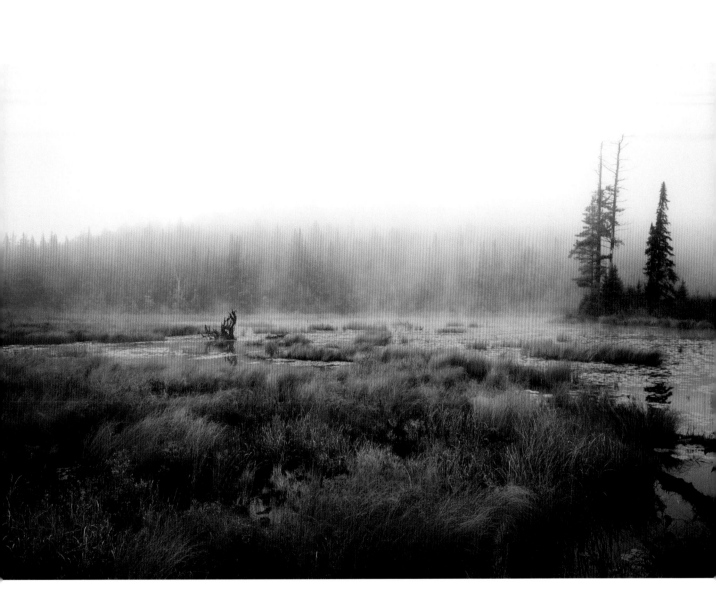

August mist, Ring-neck Pond

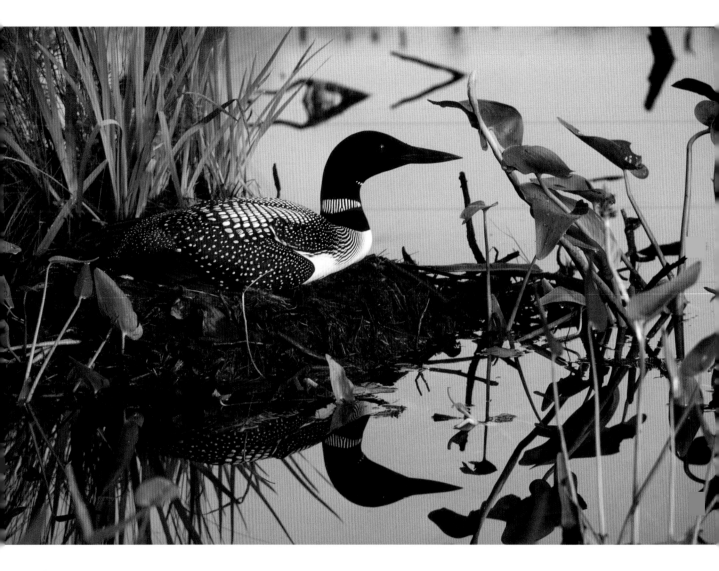

Common Loon on nest, Tanamakoon channel

OPPOSITE: Pipewort dancers, Pewee Lake

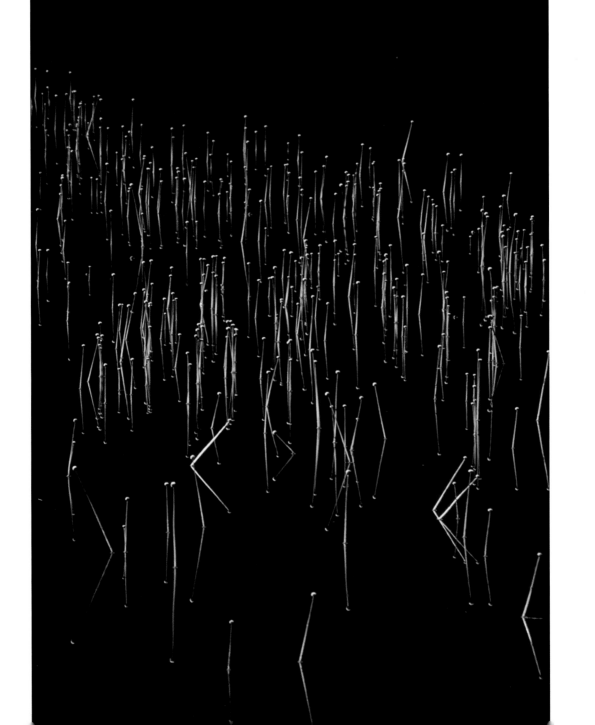

59

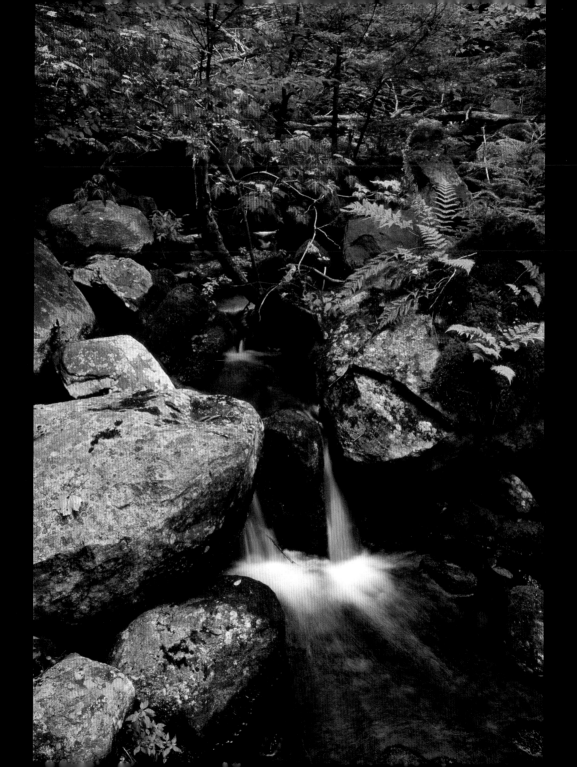

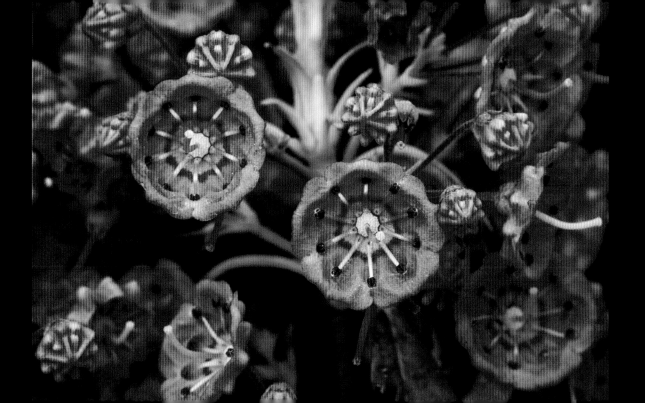

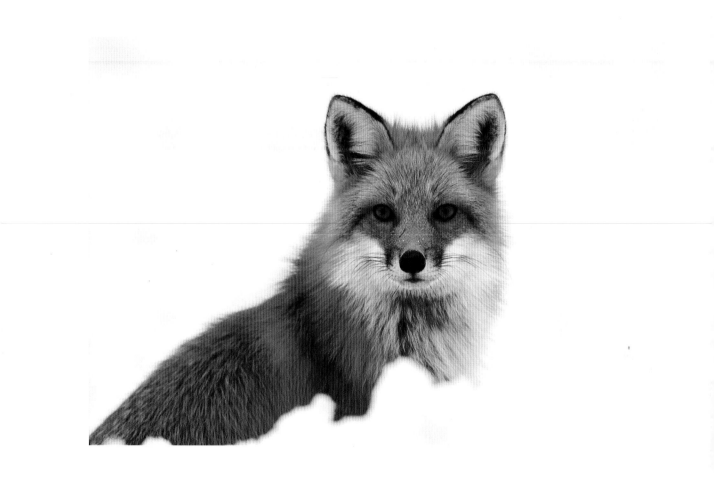

Red Fox, Found Lake

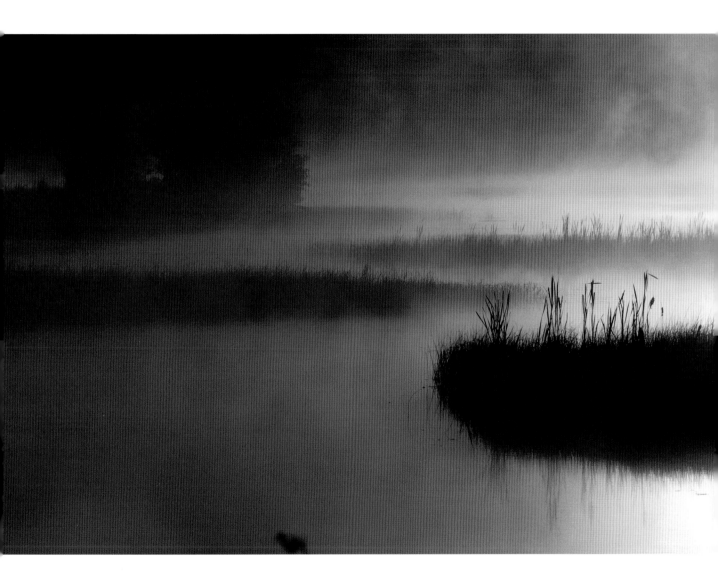

Dawn fire, Costello Creek

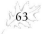

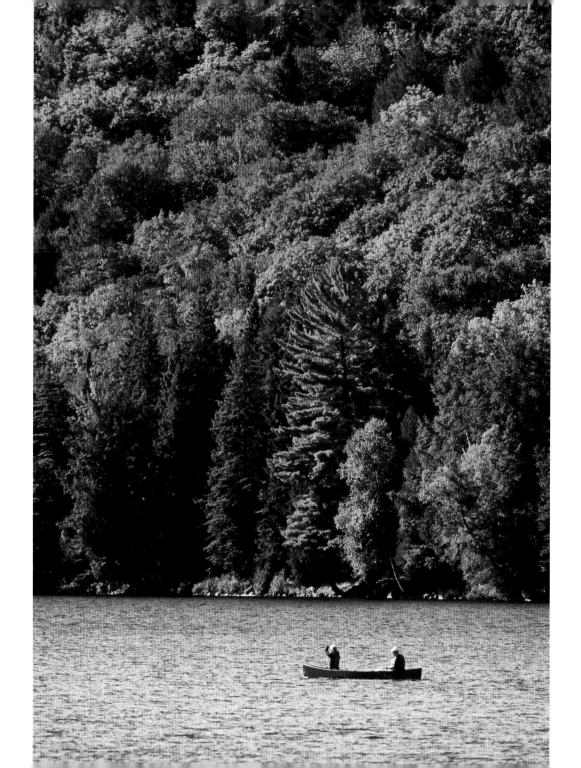

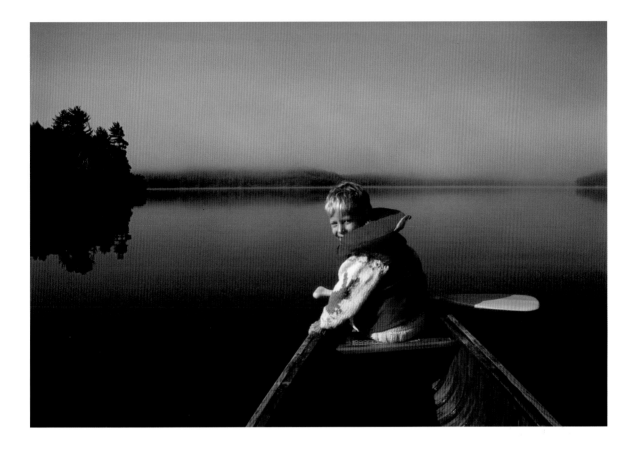

Happy paddler, Cedar Lake

OPPOSITE: Autumn outing, Lake of Two Rivers

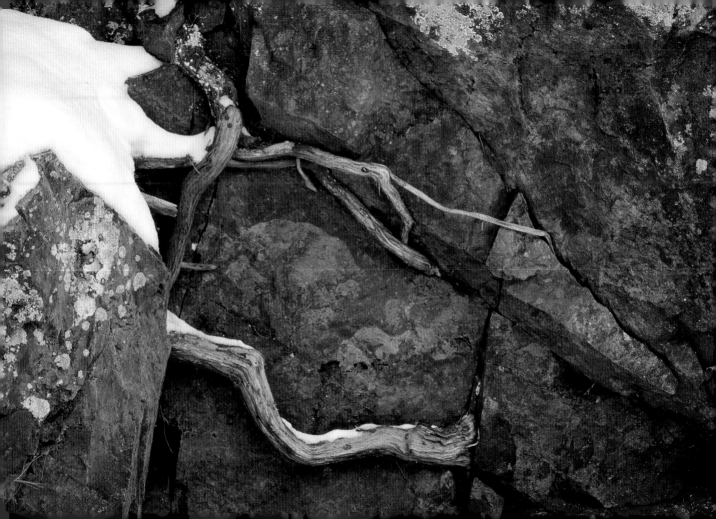

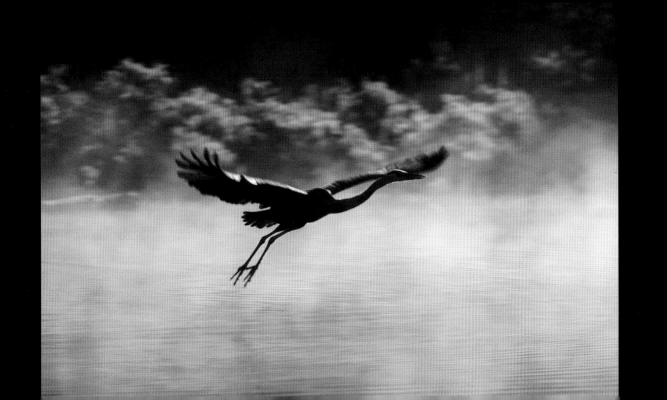

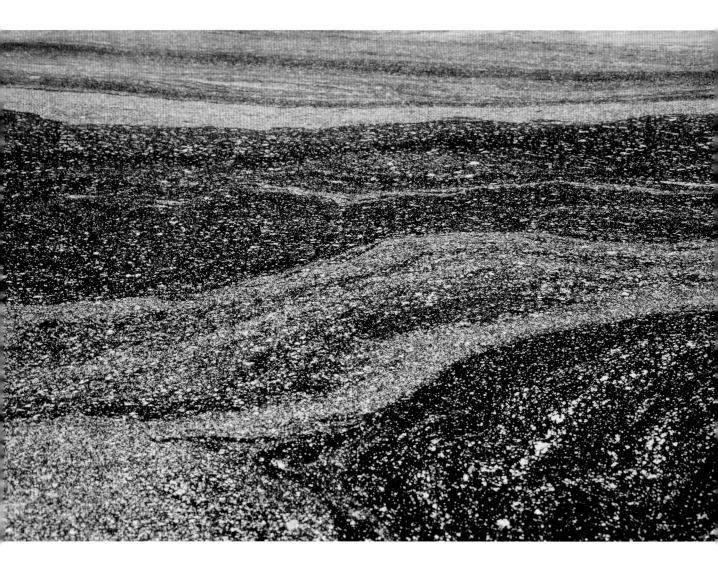

Pine pollen, Barron River

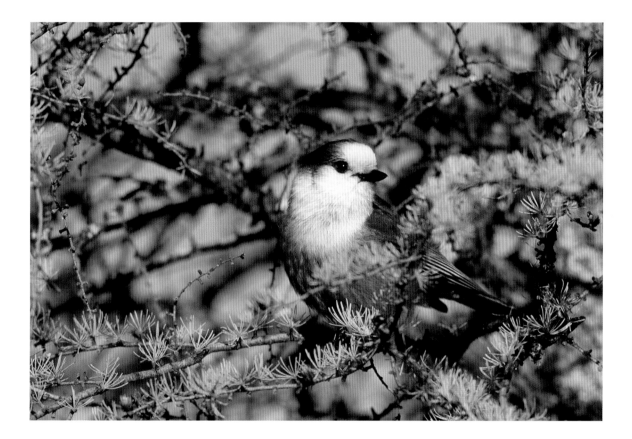

Gray Jay in autumn Tamarack, West Rose Lake

Pines at sunset, Tanamakoon Lake

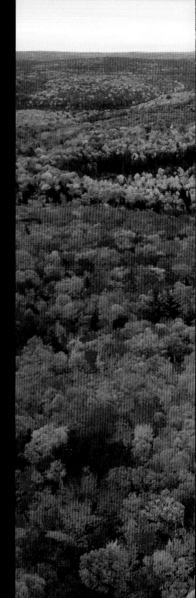

September in the western highlands

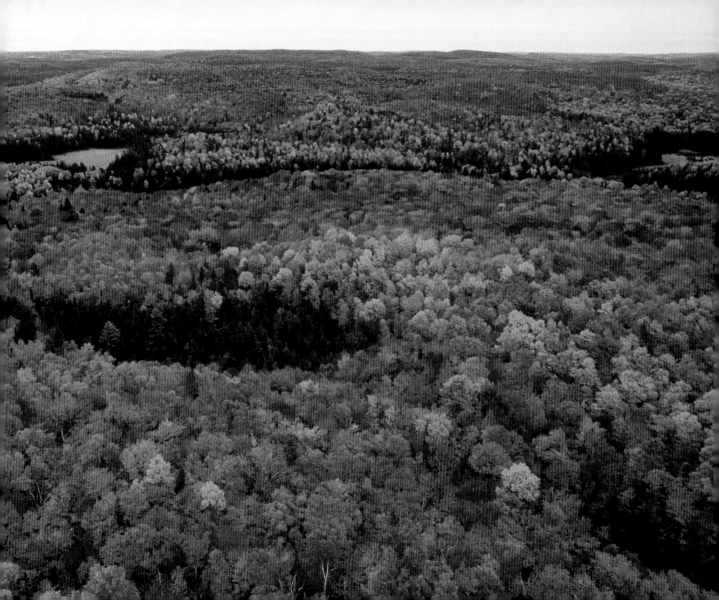

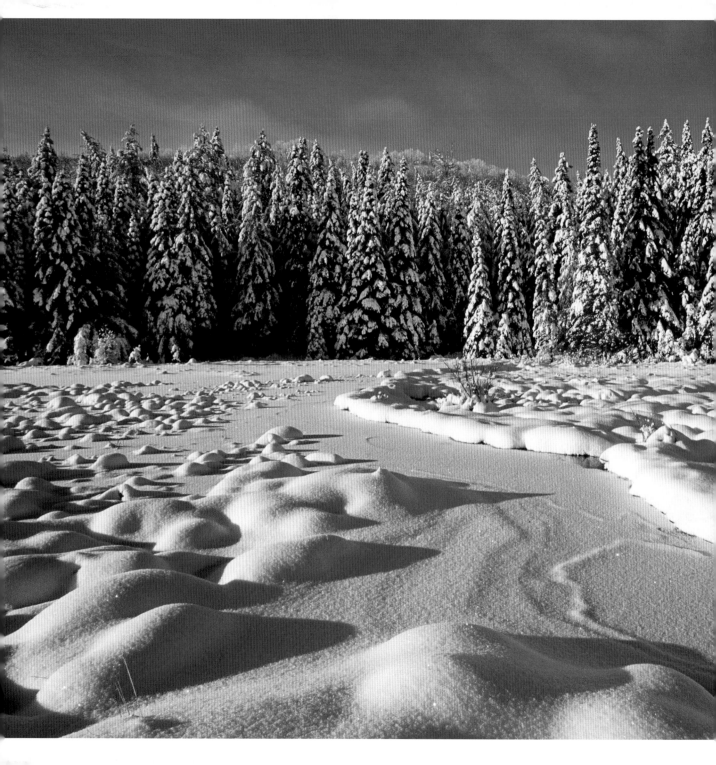

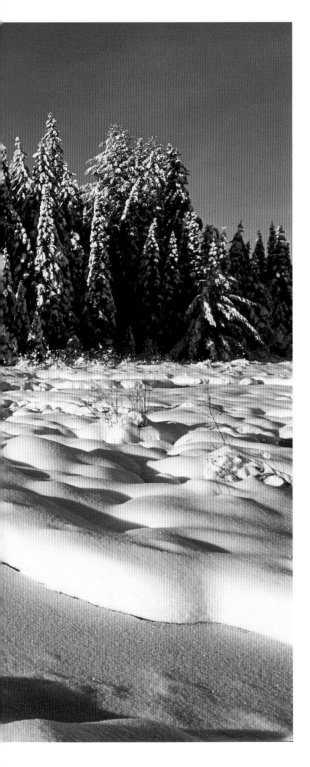

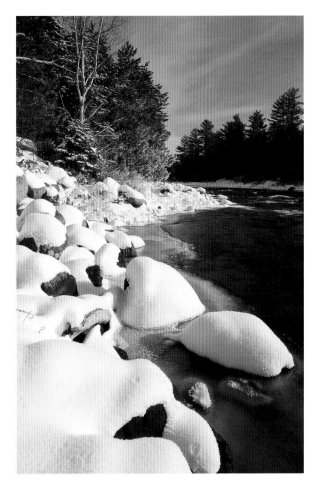

January at Poplar Rapids

Ring-neck Pond after snowfall

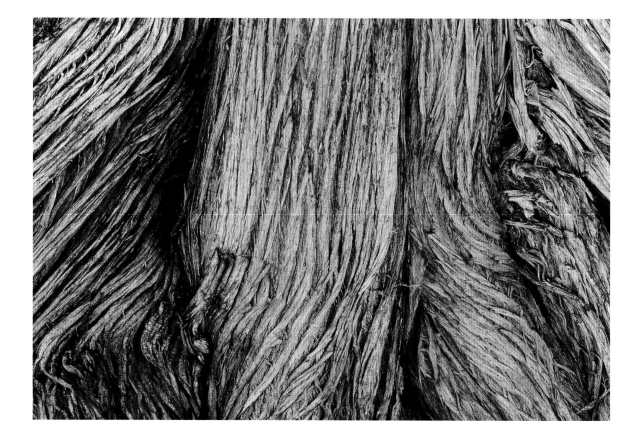

Ancient White Cedar, Barron River

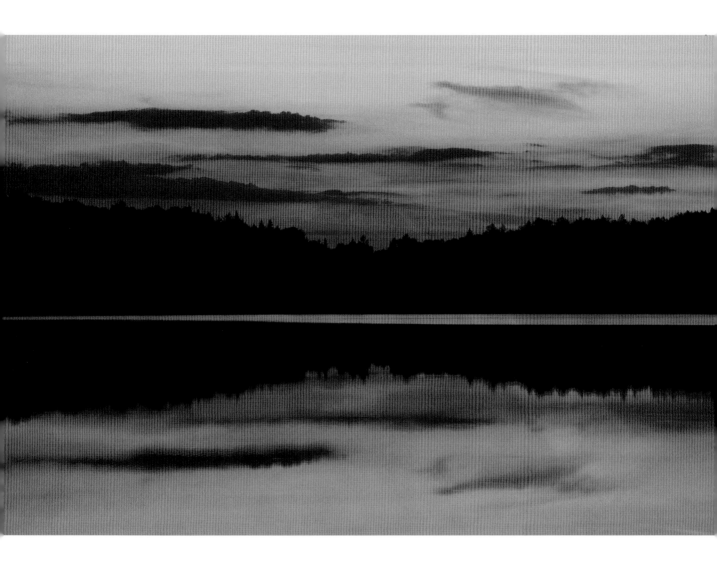

Day's end, Lake of Two Rivers

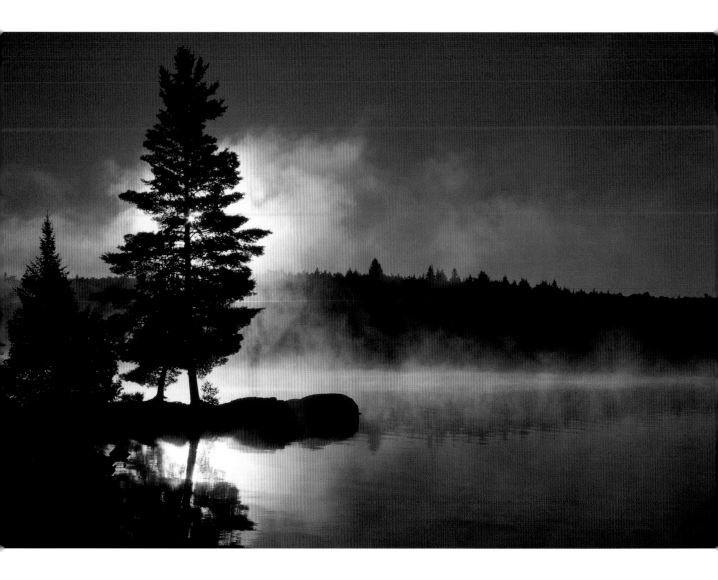

Dawn spirit, Smoke Lake

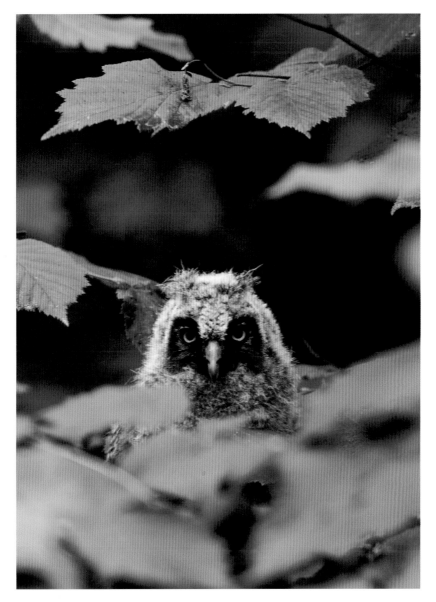

Baby Long-eared Owl, Pog Lake

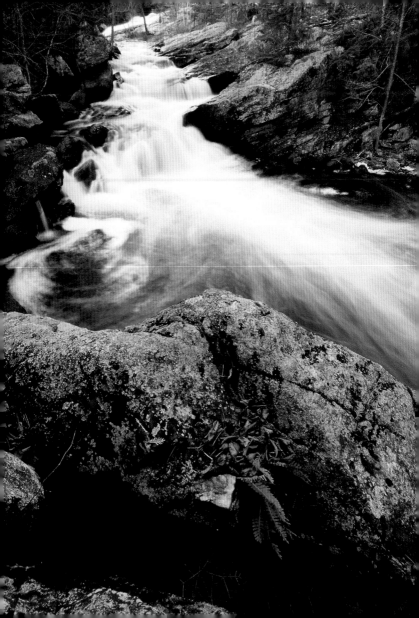

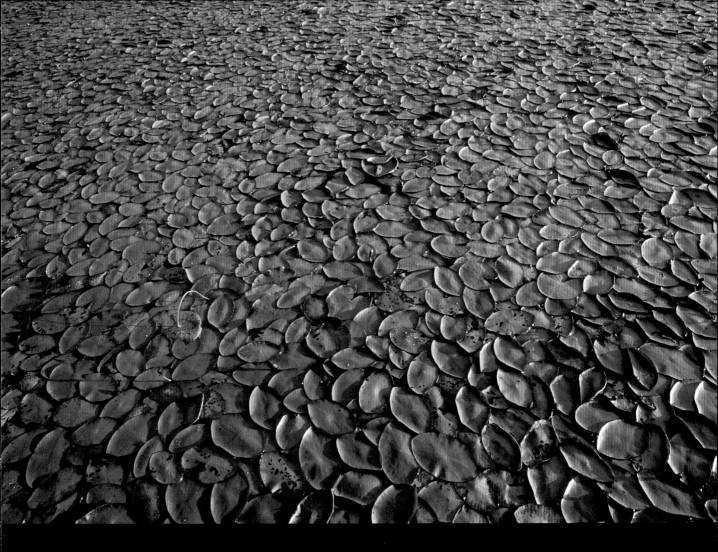

Water-shield tapestry, pond on Ahme Creek

OPPOSITE: High Falls, York River

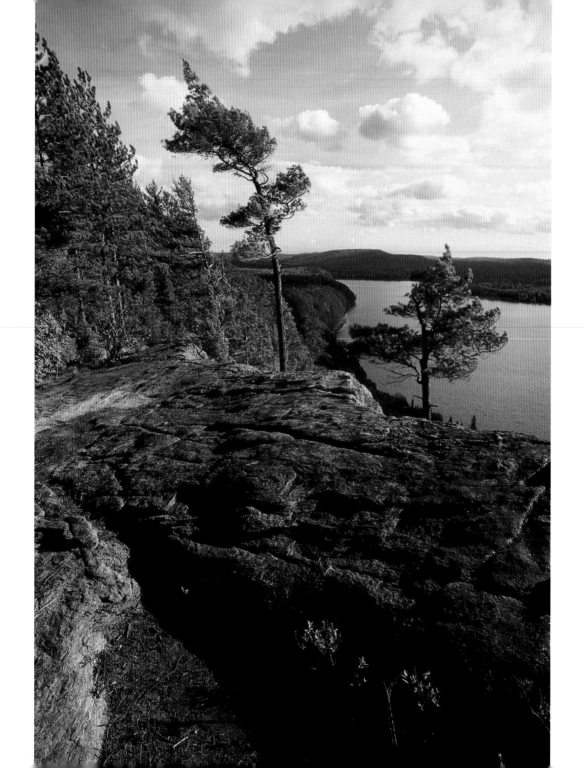
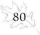

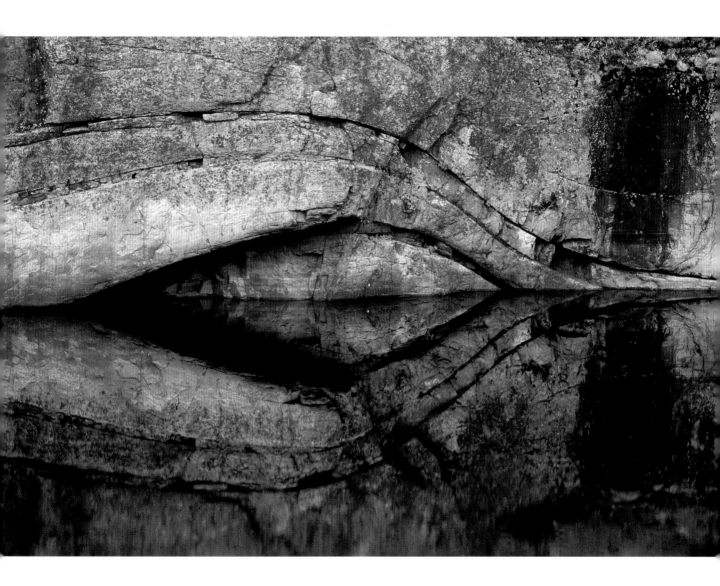

One gneiss eye, Petawawa River

OPPOSITE: Wind-blown pines, Centennial Ridges Trail

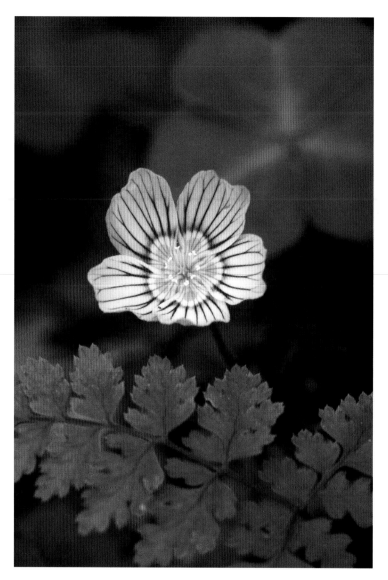

Wood Sorrel

OPPOSITE: White Water-lilies near Ring-neck Pond

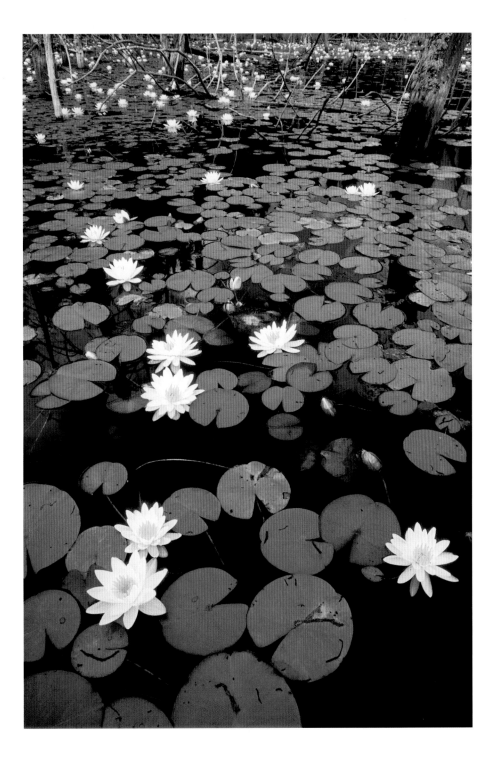

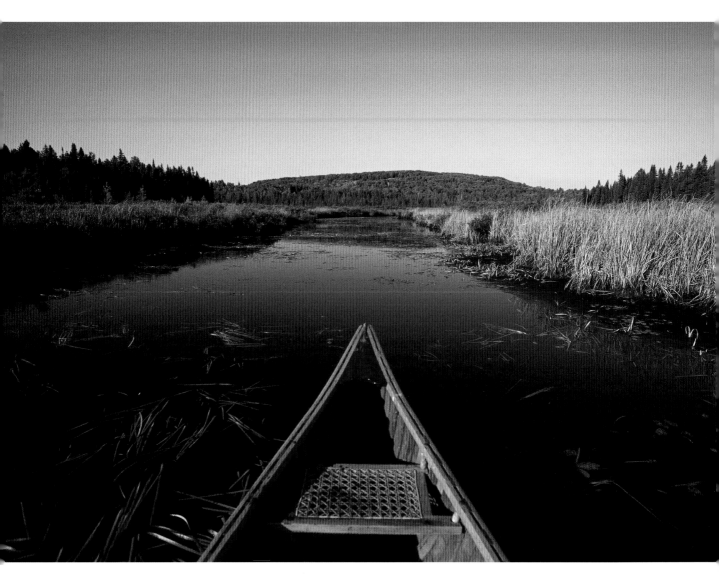

Costello Creek

OPPOSITE: Sugar Maple near Cache Lake

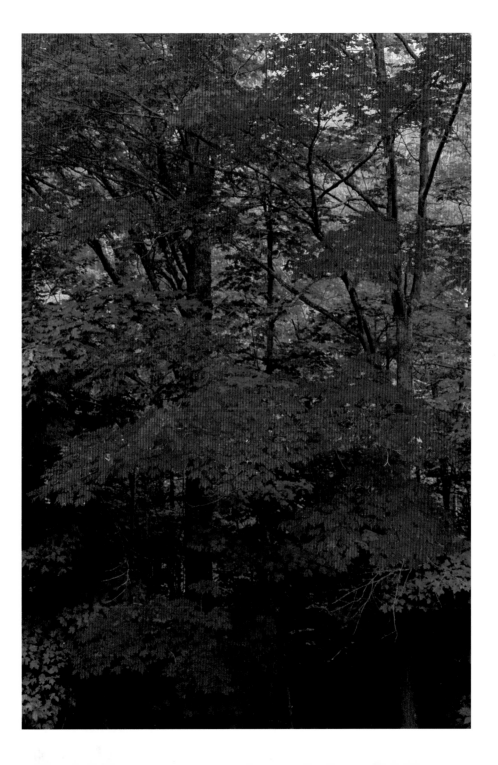

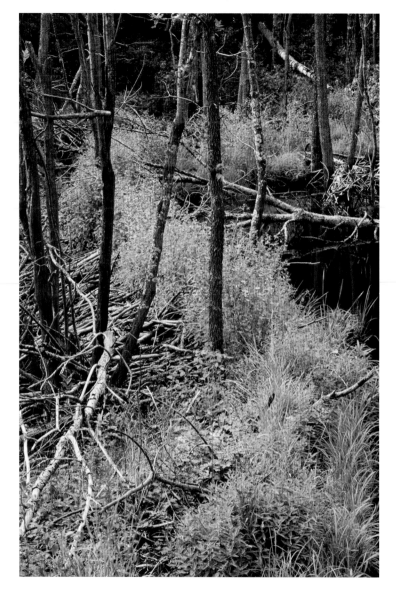

Jewelweed on old beaver dam near Mallard Lake

OPPOSITE: Bog Copper on Rose Pogonia, McManus Lake bog

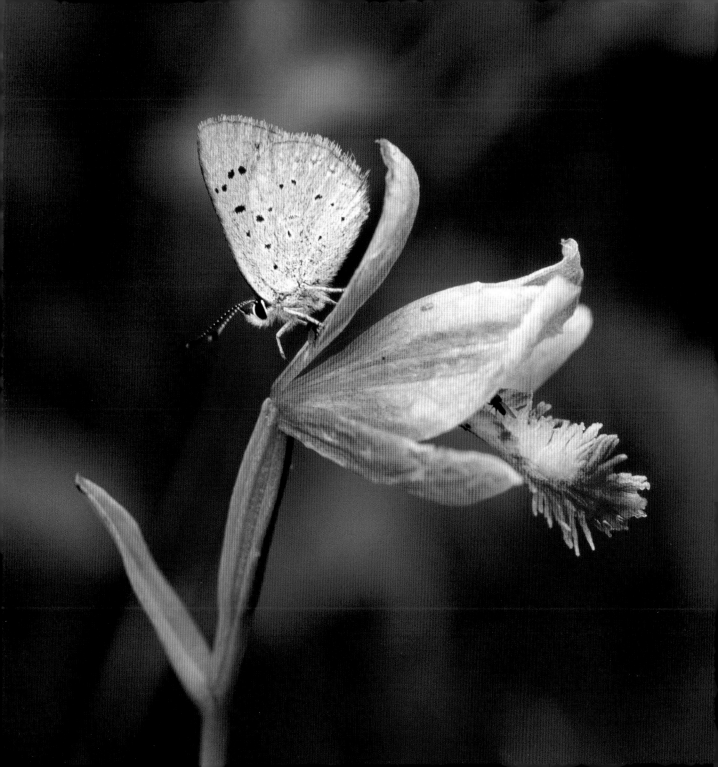

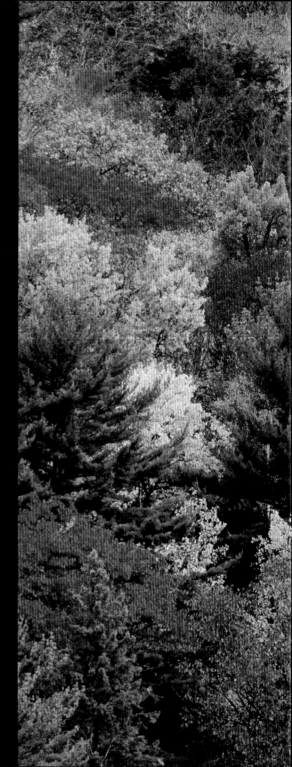

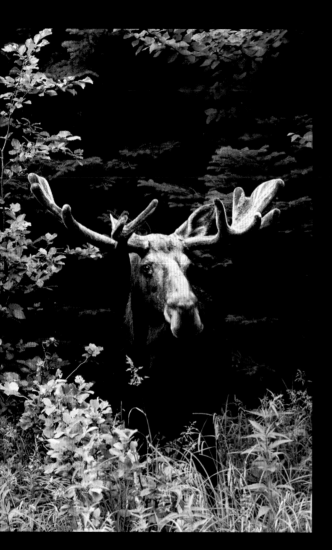

Bull moose, Track and Tower Trail

October hillside, Big Pines Trail

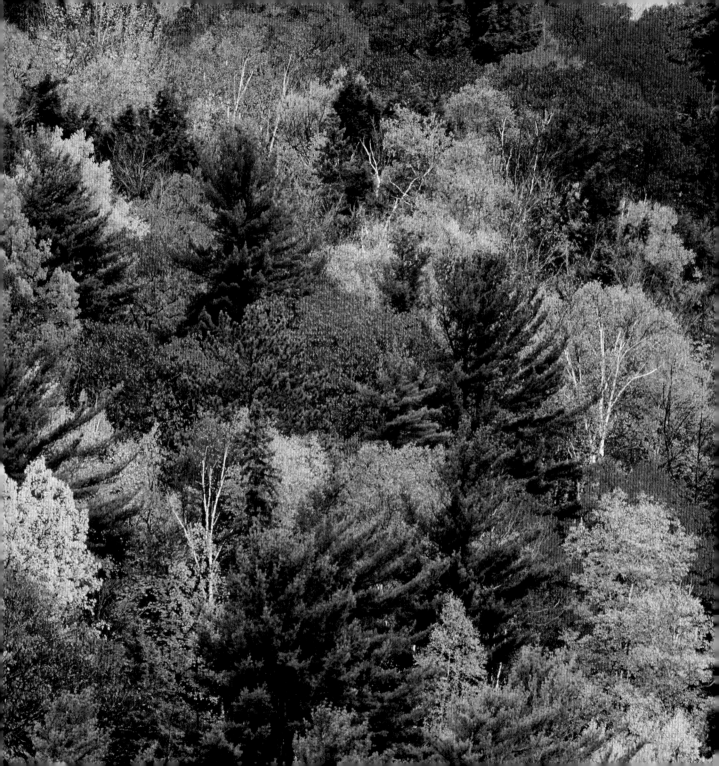

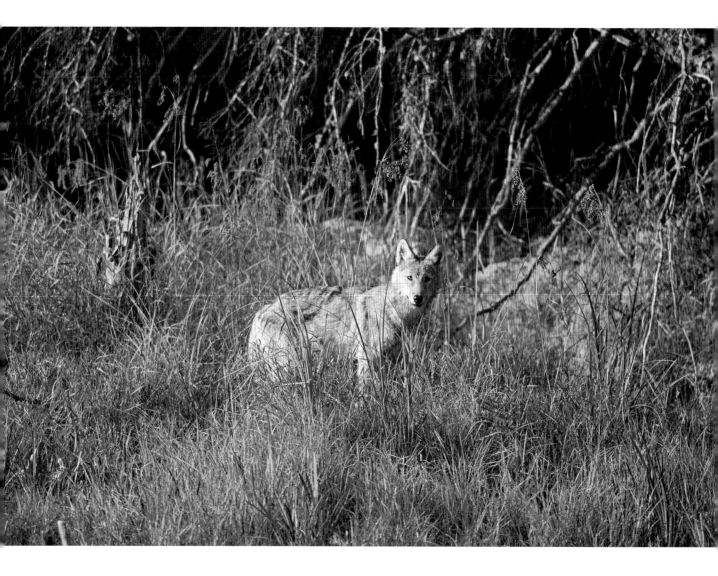

Eastern Canadian Wolf, Sunday Creek

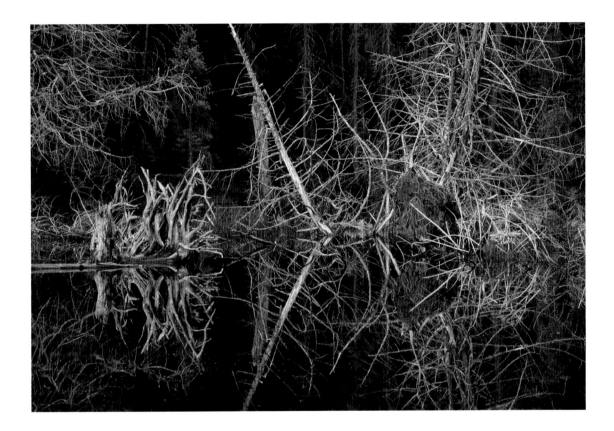

Reflections, Pitcher-plant Pond

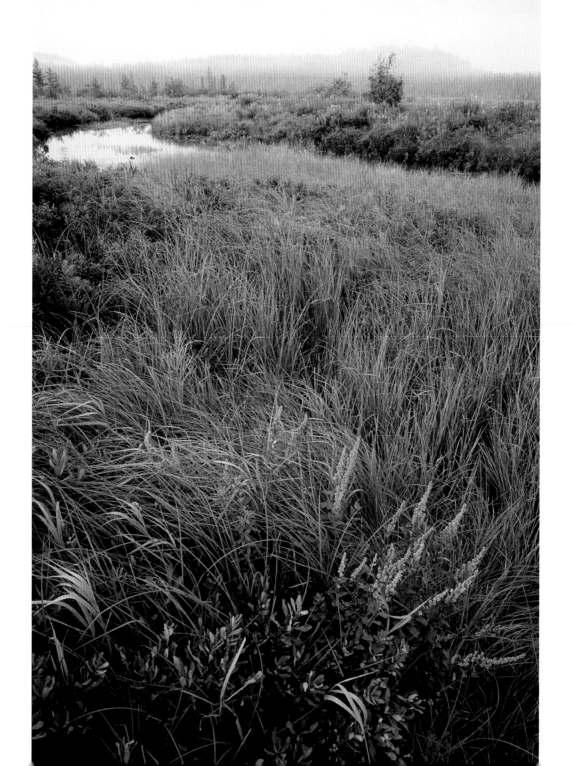

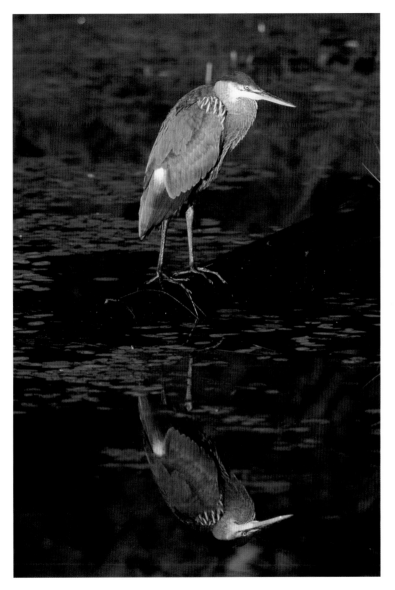

Great Blue Heron, Hermit Creek

OPPOSITE: Steeplebush, Sunday Creek

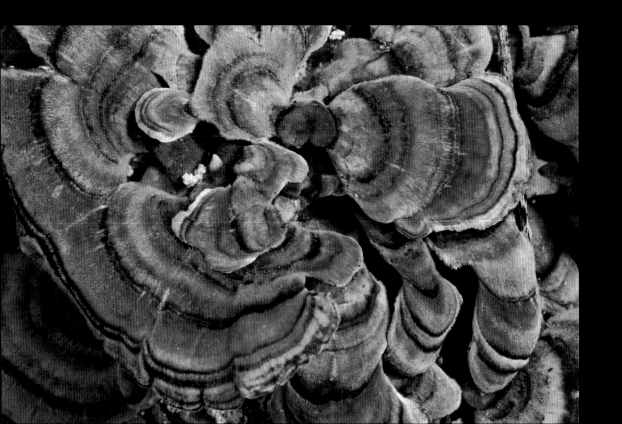

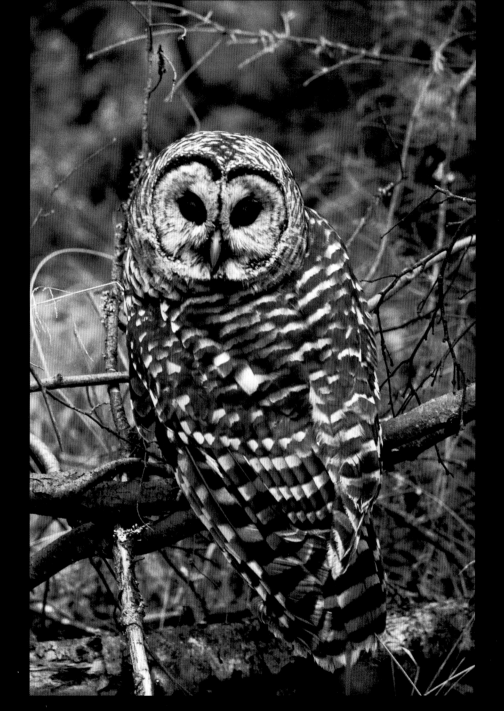

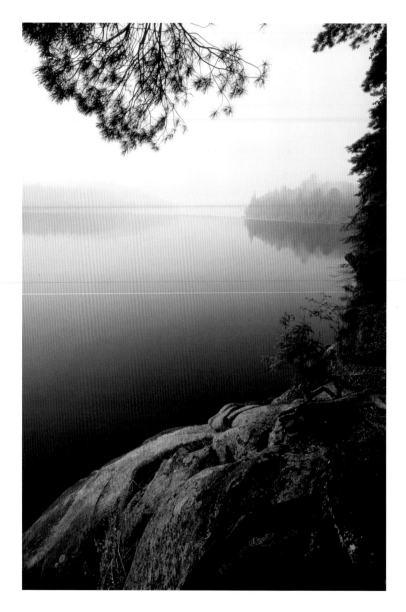

Sasajewun Lake